THE HUDSON RIVER

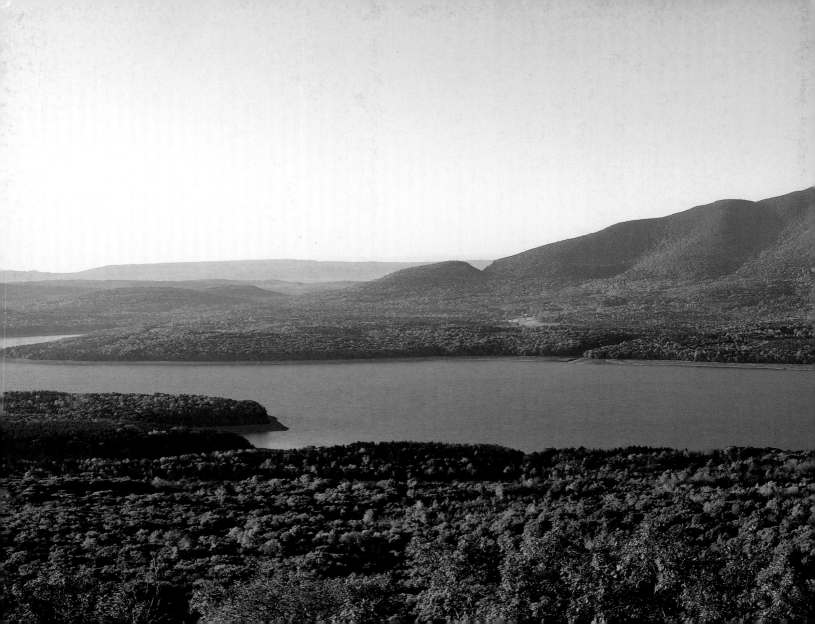

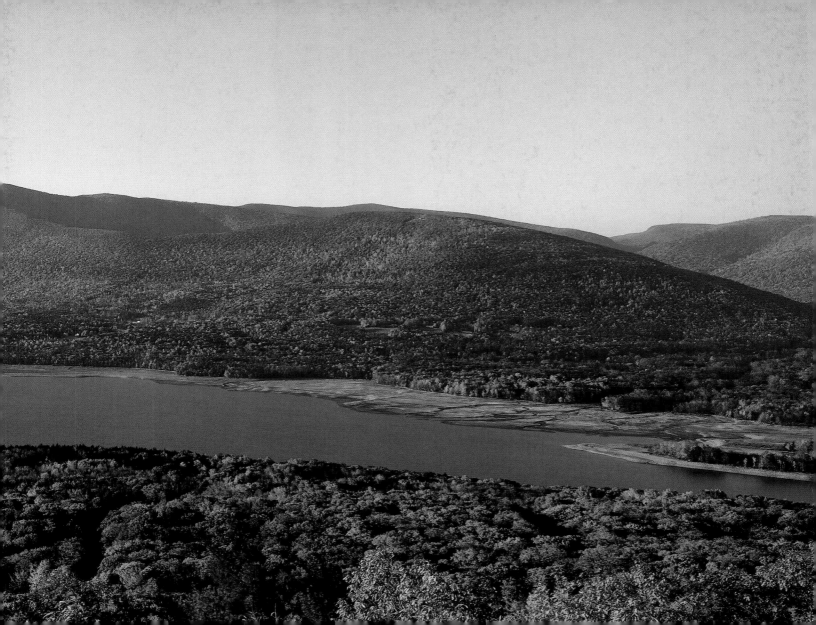

FROM TEAR OF THE CLOUDS TO MANHATTAN

THE HUDS

ON RIVER

PHOTOGRAPHS BY JAKE RAJS INTRODUCTION BY JOAN K. DAVIDSON AFTERWORD BY ARTHUR G. ADAMS

THE MONACELLI PRESS

CONTENTS

12
INTRODUCTION
Joan K. Davidson

18
THE HUDSON
OF BEAUTY

FROM TEAR
OF THE CLOUDS TO
SARATOGA SPRINGS

*With selections from
Nathaniel Parker Willis
Verplanck Colvin
Benson John Lossing
James Kirke Paulding
Edna Ferber*

58
THE HUDSON
OF HISTORY

FROM WATERFORD
TO KINGSTON

With selections from
DeWitt Clinton
Benson John Lossing
Nathaniel Parker Willis
Washington Irving
Wallace Bruce
John K. Howat
James Fenimore Cooper
Robert P. McIntosh
John Burroughs
Cynthia Owen Philip

120
THE HUDSON
OF LITERATURE

FROM HYDE PARK
TO TARRYTOWN

With selections from
John W. Harrington
Irving Elting
Charles S. Bannerman
John Beardsley
Charles Dickens
Benson John Lossing

186
THE HUDSON
OF COMMERCE

FROM THE TAPPAN ZEE
BRIDGE TO THE STATUE
OF LIBERTY

With selections from
Chistopher Morley
Raymond L. O'Brien
Hildegarde Swift and
* Lynd Ward*
Robert A. Caro
Charles Lindbergh
Charles Dickens

242
AFTERWORD
Arthur G. Adams

246
POSTSCRIPT
Jake Rajs

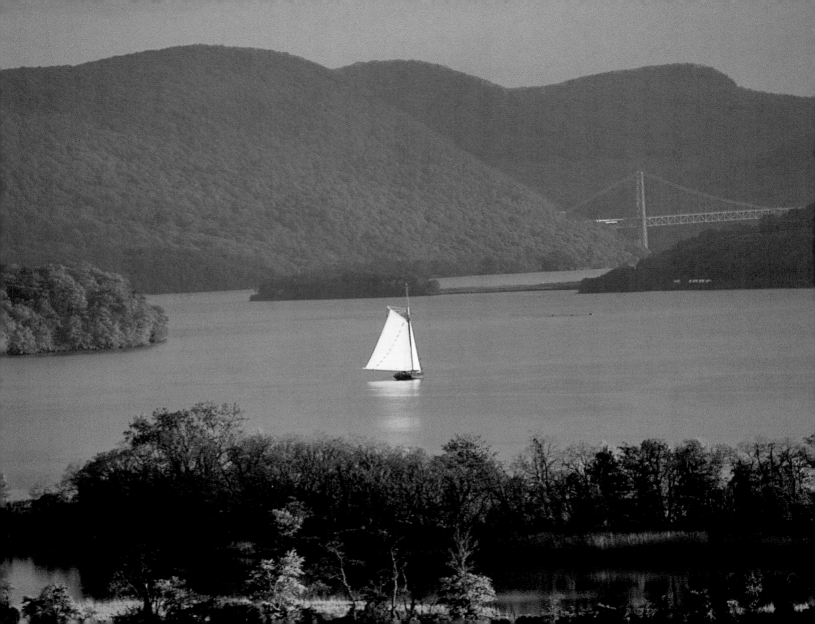

THE HUDSON, MORE THAN ANY OTHER RIVER, has a distinct personality—an absolute soul-quality. With moods as various as the longings of human life she responds to our joys in sympathetic sweetness, and soothes our sorrows as by a gentle companionship. If the Mississippi is the King of Rivers, the Hudson is, par excellence, the Queen, and continually charms by her "infinite variety." It often seems that there are in reality four separate Hudsons—the Hudson of Beauty, the Hudson of History, the Hudson of Literature, and the Hudson of Commerce. To blend them all into a loving cable reaching from heart to heart is the purpose of the writer. It has been his privilege to walk again and again every foot of its course from the wilderness to the sea, to linger beside her fountains and dream amid her historic shrines, and from many braided threads of memory it has been his hope to set forth with affectionate enthusiasm what the student or traveler wishes to see and know of her majesty and glory.

WALLACE BRUCE, *The Hudson, 1907*

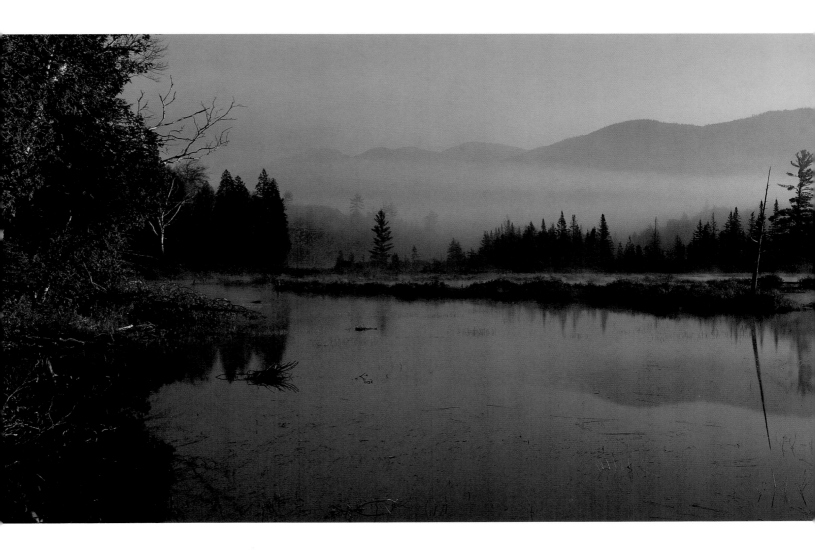

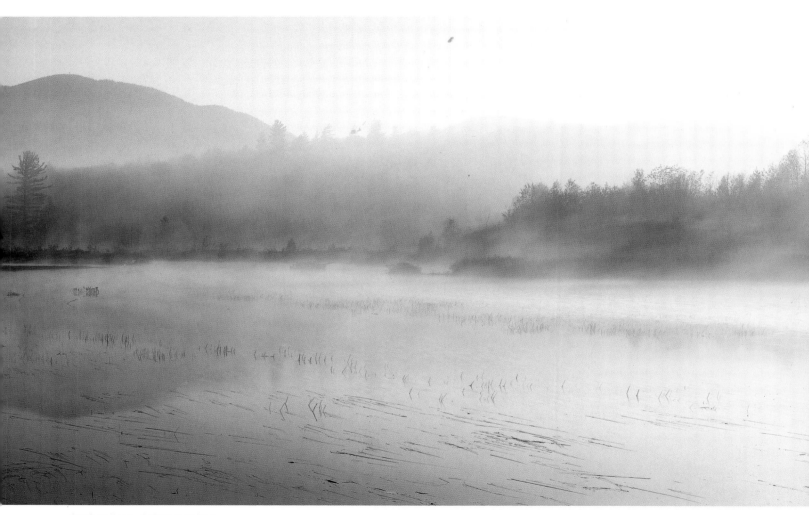

Sanford Lake, Adirondack Park.

INTRODUCTION *Joan K. Davidson*

NEW YORK'S HUDSON VALLEY belongs to all Americans—and to me alone.

For decades I have revered the valley from afar for the power of its mountains and waterways, for its vernacular and grand architecture, its classic river towns, broad farmlands, redolent history, and the most splendid of vistas—and for the mysterious symbolic power it appears to hold in the American psyche. Today it is my good fortune to live there.

The Hudson Valley of legend intrigues us and engenders pride while never letting us forget that in our country precious resources, even marvels on so vast a scale, are always in peril of diminishment and loss. The valley is a large-scale, integrated system that offers a model for states, regions, and communities throughout the land that are also wondering if local character can be preserved as economic goals are pursued. Here, intimations of our national future can be caught, if we attend.

The centerpiece of the region is the great river that runs from the Adirondacks to the sea. Only three hundred miles long, it is deep and wide. Its nether reaches ebb and flow with the salty tides of the Atlantic, and its upper end drains bubbling springs and lakes of the Catskills, Shawangunks, and Taconics.

Much can be learned in the Hudson Valley about land—how it fares in the care of public and private entities and in the face of competing claims. Seventeenth and eighteenth-century ownership of land on a colossal scale by families of rank and fortune has —through the passage of time, through circumstances, through changing mores and values—been translated from patrician excess into populist benefaction, even entitlement. The great Dutch and English Hudson Valley estates and farms, some exceeding hundreds of thousands of acres, once paraded side by side up along the Hudson shoreline. In some pockets, their remembrance is still surprisingly intact —and in one special instance, more than twenty miles of glorious riverfront, distinguished by dazzling natural and cultural landmarks, have been enshrined since 1990 as the Hudson River National Historic Landmark District, the first and one of the largest such protected areas in the nation. Some properties within this official district have entered the public realm as parks and historic sites; more remain in caring private hands. Together they protect air and water quality, plant and animal life, open views, and human-scale communities.

THE HUDSON VALLEY lays out dramatic lessons not only in landscape, agriculture, and land management, but also in the story of human habitation and in how the War for Independence was won. Here we are inspired about our culture, its early military, literary, and visual aspects as evinced in the battlefields and in the Knickerbocker writers and the Hudson River School of painters; about specialized industry; and about the modern environmental movement, which arose out of the 1960s struggle to save Storm King Mountain in the Hudson Highlands from despoliation by power plant.

We live in unsettled times when hard-won environmental advances are being rolled back, fast-moving sprawl is engulfing cities, towns, farmland, and open space across America, and the future of our communal holdings is in doubt. Never have we so needed to gain control over the destiny of our neighborhoods, local economies, their surrounding environments—and the quality of our lives.

Sharing these beliefs and working to this end is New York State's spirited population of citizen activists. They are the energetic battalions in land trusts, environmental and preservation societies, park advocacy organizations, enlightened businesses and public agencies, philanthropies, and editorial pages. In the Hudson Valley, where their

voice is especially loud and clear, they have made it possible to protect, maintain, and preserve for future generations streams and wetlands, historic buildings in towns, and in rural places, acres of park and farmland, and scenic views in record numbers. So far so good . . .

Jake Rajs's elegant photographs along with the apt words chosen by Arthur Adams bring to life the heart and soul of a unique landscape. In this handsome and dramatic book we see the richness of natural resources—wildlife, fish, deer; mountains and forests, marshes, rocks; uplands, islands, farm country. We read the everlasting accounts of work and events and the passage of time as marked by old ships and forts, bridges and dams, lighthouses, docks, factories, and silos. We rejoice in the dailiness of it, attested by country roads, wood fences, and vegetable gardens. We acknowledge raw brick commercial buildings and the hardworking houses of ancient river towns, and we find New York, the splendid city, revealed in a fresh way.

Perhaps most remarkably, here we can almost taste Hudson Valley weather—emphatic seasons, grandeur of cloud and sunset; cool waters in river and stream, cataract and bay, mist and rain, the calm and the storm, the distant view . . .

THESE ARE THE WONDERS that inform my own more modest Hudson Valley.

Some twenty years ago a perfect property came into my life and I into its life. My sprawling house is more than a hundred years old, solidly built to an idiosyncratic plan. Beautiful waste space, as only the late-nineteenth-century house know how to waste it, expands the house, manifesting in every day life the Hudson Valley's spaciousness, historic aspect, and joyous eccentricity. The house sits on a bluff above the river, facing the Catskills—the view so beloved of the painters—keeping the Hudson with me, early and late.

This happy circumstance underscores my profound wish that the Valley will thrive, and, of course, move ahead—and remain the same. Such is the conundrum—can we hold on to the (everchanging) places we love?—that lurks behind this evocation of a magnificent river and its valley, even as the natural and manmade glories in the book you hold in your hand are cause for celebration.

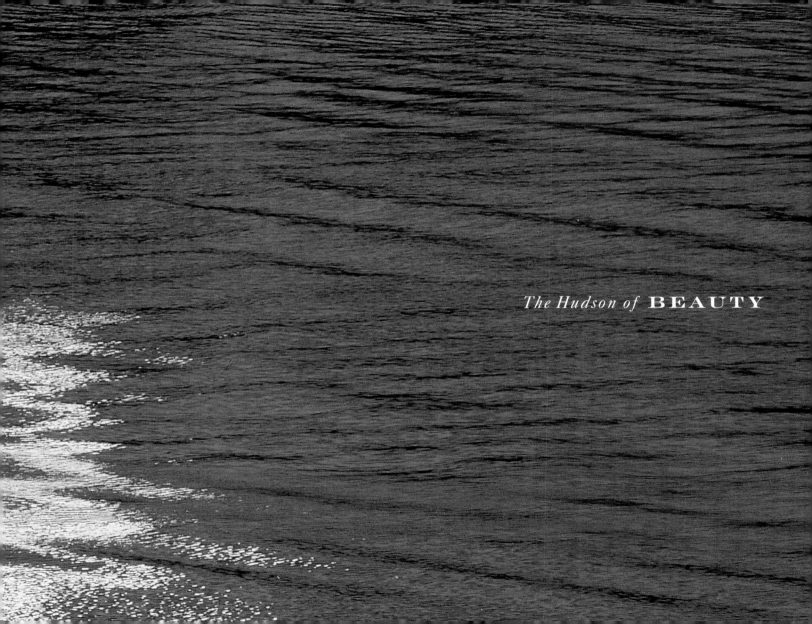

The Hudson of **BEAUTY**

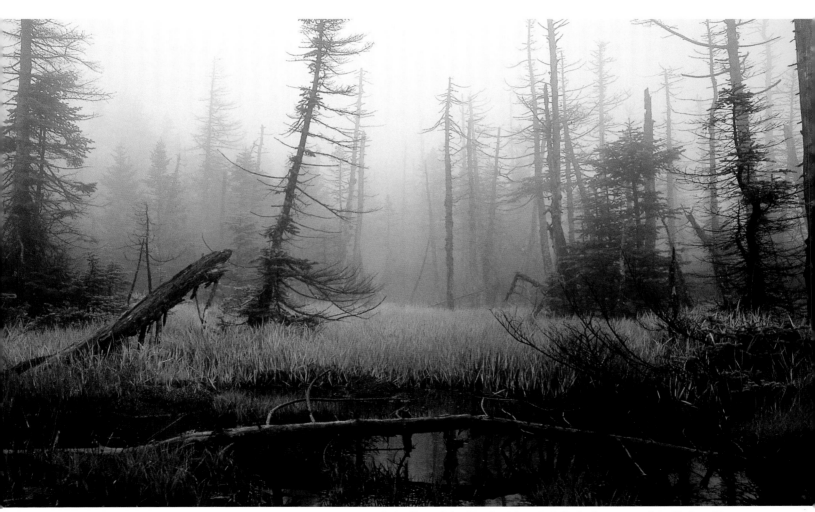

Lake Tear of the Clouds, Adirondack Park, the source of the Hudson River.

SOME OBSERVER OF NATURE offered a considerable reward for two blades of striped grass exactly similar. The infinite diversity, of which this is one instance, exists in a thousand other features of Nature, but in none more strikingly than in the scenery of rivers. What two in the world are alike? How often does the attempt fail to compare the Hudson with the Rhine—the two, perhaps among celebrated rivers, which are the nearest in resemblance? Yet looking at the first determination of a river's course, and the natural operation of its search for the sea, one would suppose that, in a thousand features, their valley would scarce be distinguishable.

I think, of all excitements in the world, that of the first discovery and exploration of a noble river, must be the most eager and enjoyable. Fancy "the bold Englishman," as the Dutch called Hendrich Hudson, steering his little yacht, the Halve-Mane, for the first time through the highlands! Imagine his anxiety for the channel, forgotten as he gazed up at the towering rocks, and round the green shores, and onward, past point and opening bend, miles away into the heart of the country;

yet with no lessening of the glorious stream beneath him, and no decrease of promise in the bold and luxuriant shores! Picture him lying at anchor below Newburgh, with the dark pass of the "Wey-Gat" frowning behind him, the lofty and blue Cattskills beyond, and the hillsides around covered with the red lords of the soil, exhibiting only less wonder than friendliness. And how beautifully was the assurance of welcome expressed, when the "very kind old man" brought a bunch of arrows, and broke them before the stranger, to induce him to partake fearlessly of his hospitality!

The qualities of the Hudson are those most likely to impress a stranger. It chances felicitously that the traveller's first entrance beyond the sea-board is usually made by the steamer to Albany. The grand and imposing outlines of rock and horizon answer to his anticipations of the magnificence of a new world; and if he finds smaller rivers and softer scenery beyond, it strikes him but as a slighter lineament of a more enlarged design.

To the great majority of tastes, this, too, is the scenery to live among. The

Hudson River Gorge, Adirondack Park.

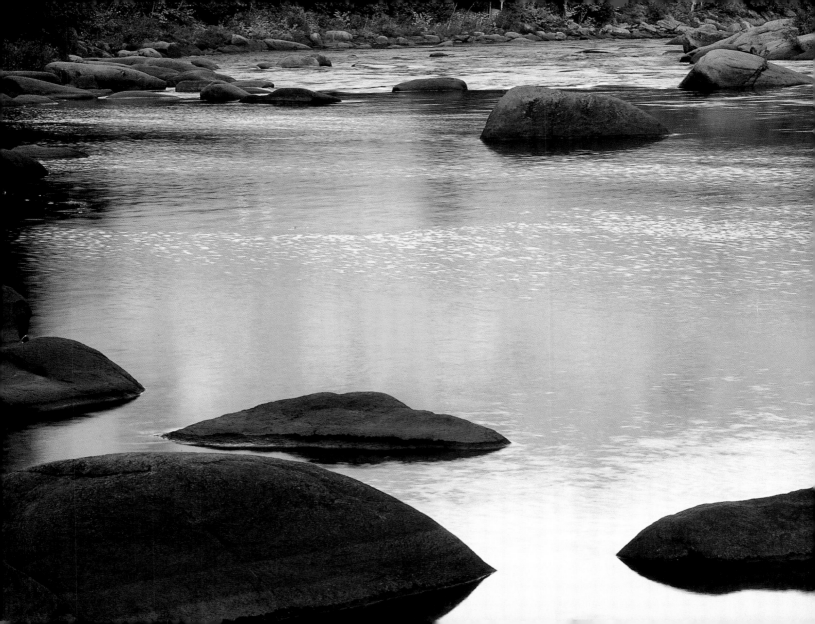

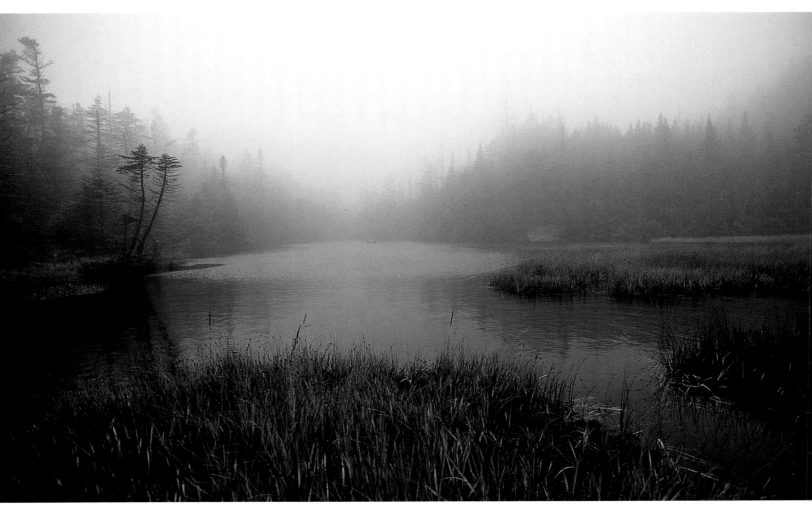

Lake Tear of the Clouds, Adirondack Park.

stronger lines of natural beauty affect most tastes; and there are few who would select country residence by beauty at all, who would not sacrifice something to their preference for the neighborhood of sublime scenery. The quiet, the merely rural— a thread of a rivulet instead of a broad river—a small and secluded valley, rather than a wide extent of view, bounded by bold mountains, is the choice of but a few. The Hudson, therefore, stands usually foremost in men's aspirations for escape from the turmoil of cities, but, to my taste, though there are none more desireable to see, there are sweeter rivers to live upon.

NATHANIEL PARKER WILLIS, *The Four Rivers: The Hudson, the Chenango, the Mohawk, the Susquehanna, 1849*

... A minute, unpretending tear of the clouds, as it were, a lonely pool,

shivering in the breezes of the mountains, and sending its limpid surplus

through Feldspar Brook to the Opalescent River, the wellspring of the Hudson.

VERPLANCK COLVIN, *Annual Report on the Topographical Survey of the Adirondack Region, 1872*

Lake Tear of the Clouds, Adirondack Park.

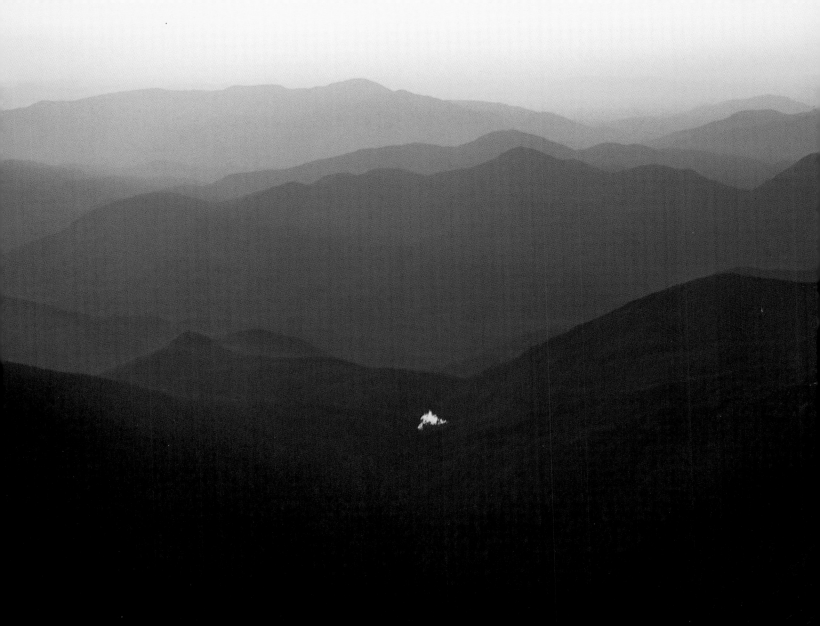

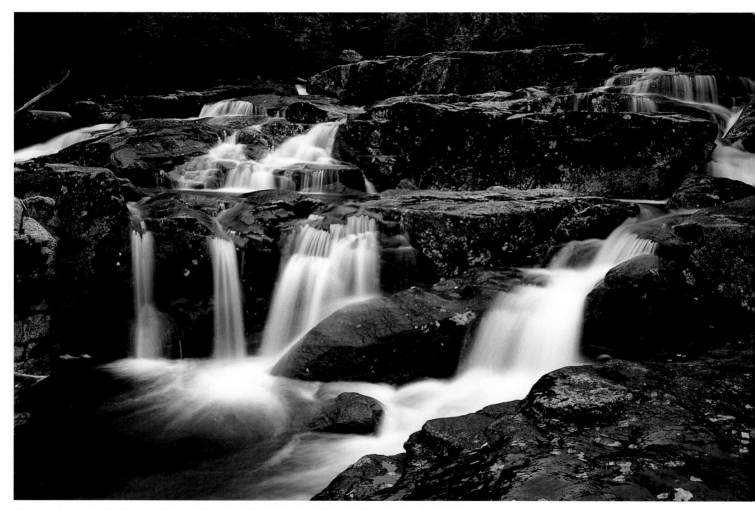

Above and opposite: Opalescent River, Adirondack Park. *Overleaf:* Lake Colden, Adirondack Park.

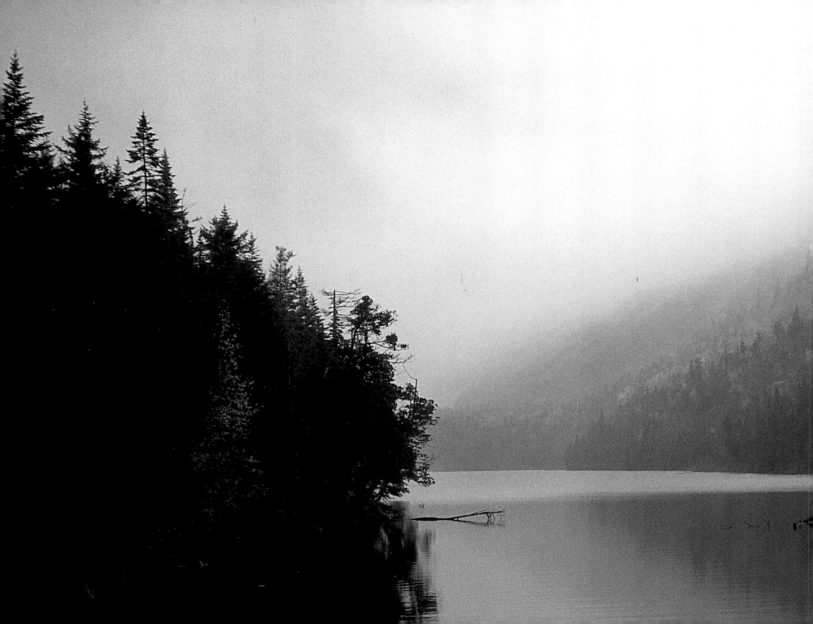

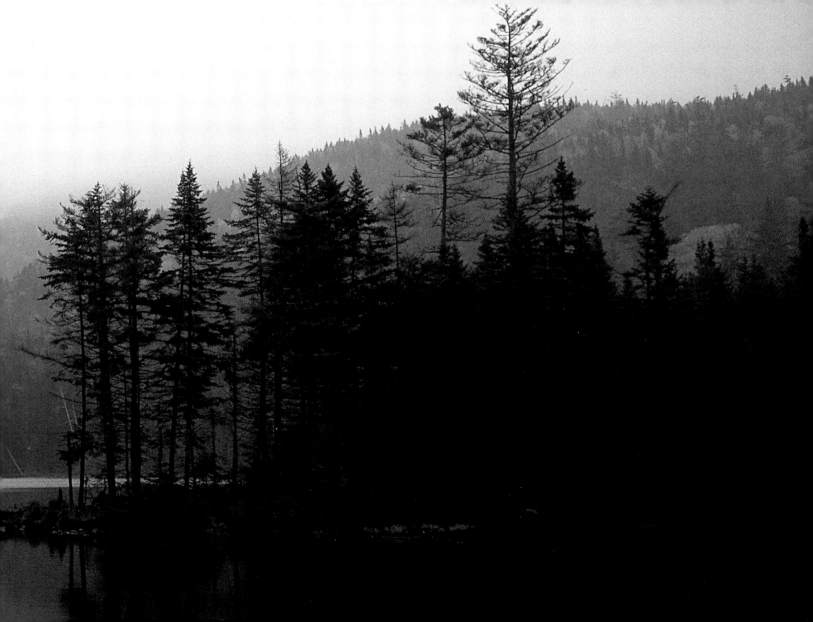

WELL PREPARED WITH ALL necessaries excepting flannel overshirts, we set out from Adirondack on the afternoon of the 30th of August, our guides with their packs leading the way. The morning had been misty, but the atmosphere was then clear and cool. We crossed the Hudson three-fourths of a mile below Henderson Lake, upon a rude bridge, made our way through a clearing tangled with tall raspberry shrubs full of fruit, for nearly half a mile, and then entered the deep and solemn forest, composed of birch, maple, cedar, hemlock, spruce, and tall pine trees. Our way was over a level for three-fourths of a mile, to the outlet of Calamity Pond. We crossed it at a beautiful cascade, and then commenced ascending by a sinuous mountain path, across which many huge tree had been cast by the wind.

BENSON JOHN LOSSING, *The Hudson: From the Wilderness to the Sea, 1866*

Avalanche Lake, Adirondack Park.
Overleaf, left: Meeting of the Indian and Hudson Rivers, Adirondack Park. *Overleaf, right:* Sanford Lake, Adirondack Park.

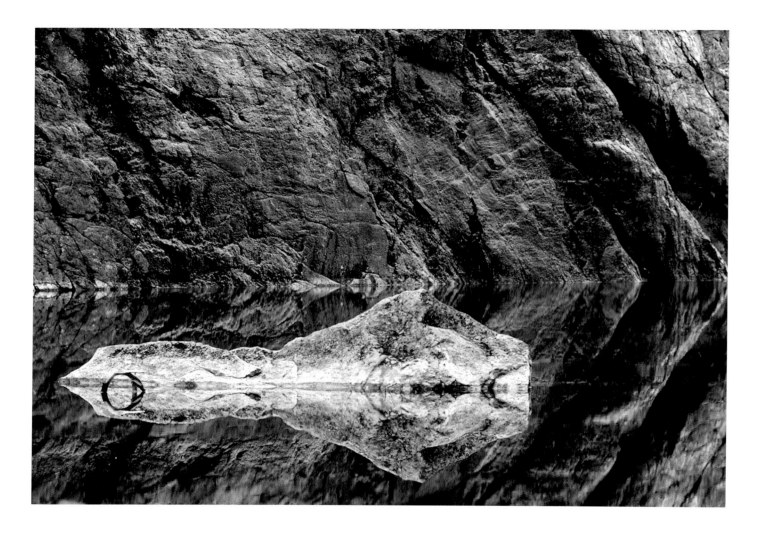

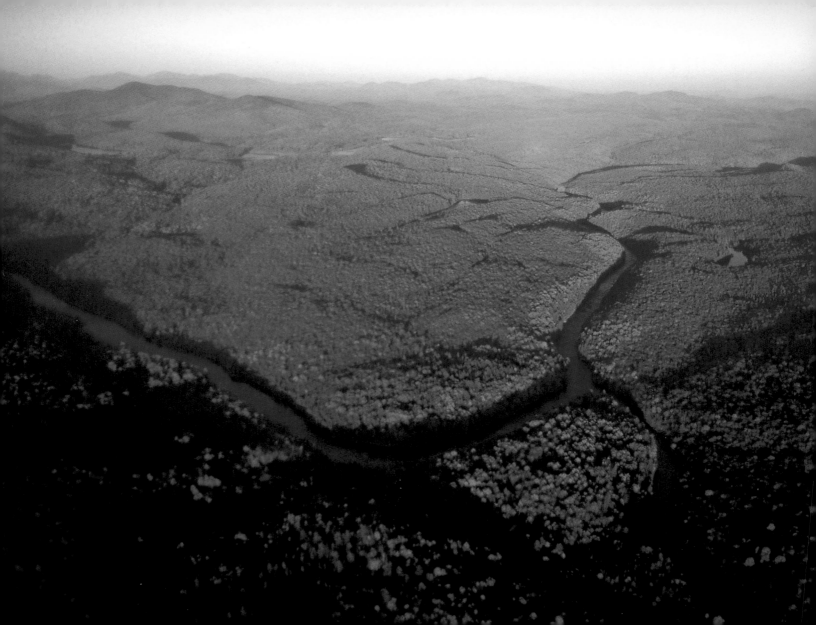

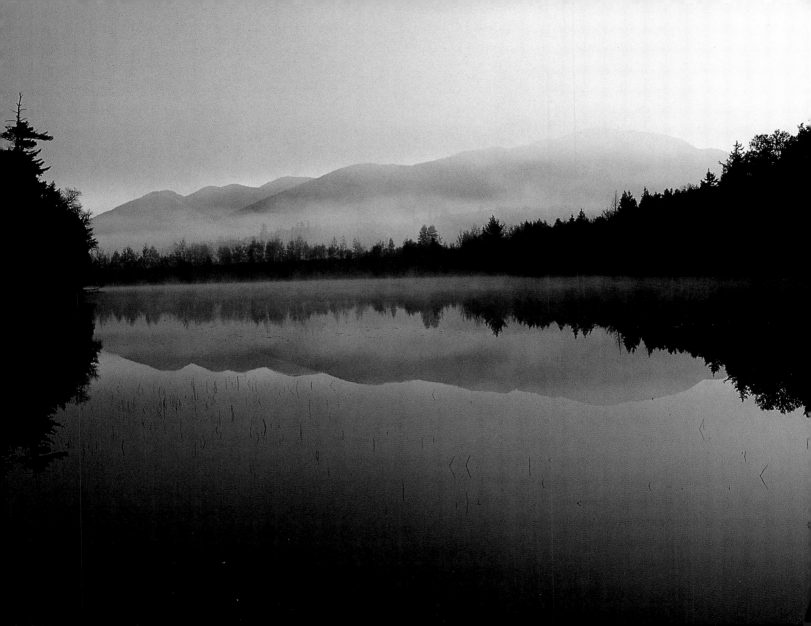

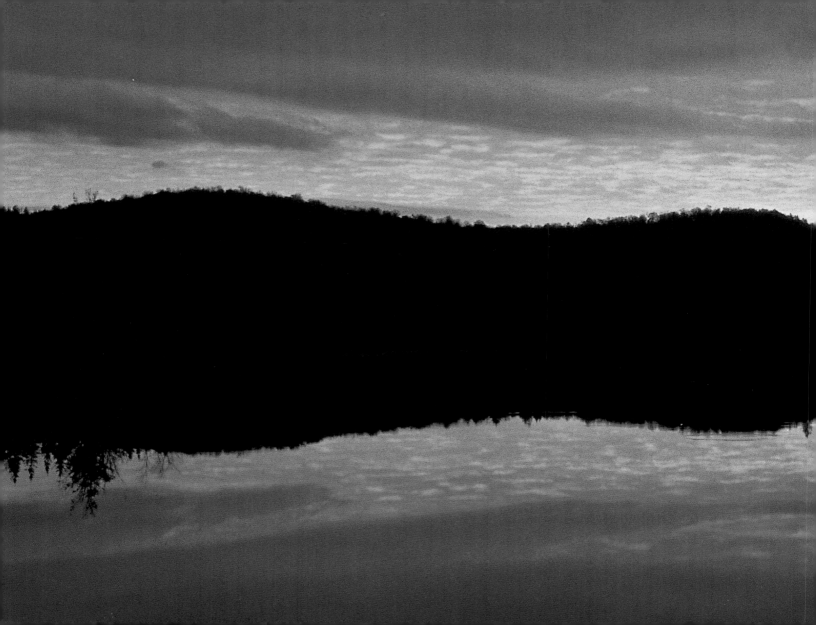

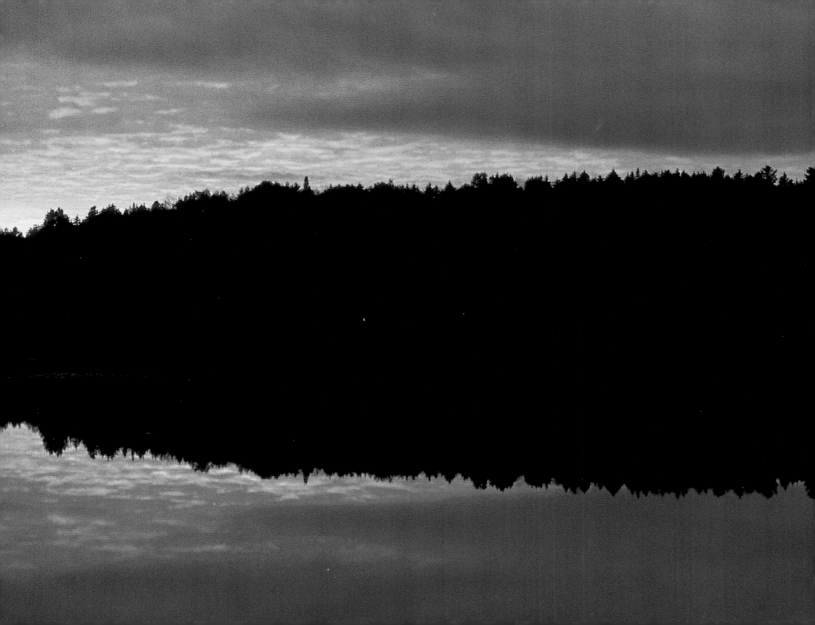

THE LABOURS OF our hero's voyage were far greater than the dangers. He and his trusty squire had to breast the swift current from morning until night, and win every foot of their way by skill and exertion combined. Sometimes the current swept through a long, narrow reach, between ledges of rocks that crowded it into increasing depth and velocity,—at others it wound its devious way by sudden, abrupt turnings, bristling on every side with sharp projections either just above or just below the surface; and at others they were obliged to unlade their light canoe, and carry its lading fairly round some impassable obstruction. In this manner they proceeded, winning their way inch by inch—watching with an attention, an anxiety never to be relaxed for a moment without the danger, nay, the certainty, of the shipwreck of their frail canoe, the loss of their cargo, and the disgrace of an unsuccessful voyage. This last was what every young man feared beyond the dangers and privations of his enterprise.

JAMES KIRKE PAULDING, *The Dutchman's Fireside, 1831*

Rafters in the Blue Ledge area, Adirondack Park.
Preceding pages: Lake Harris, Adirondack Park. *Overleaf:* Adirondack Mountains, Adirondack Park.

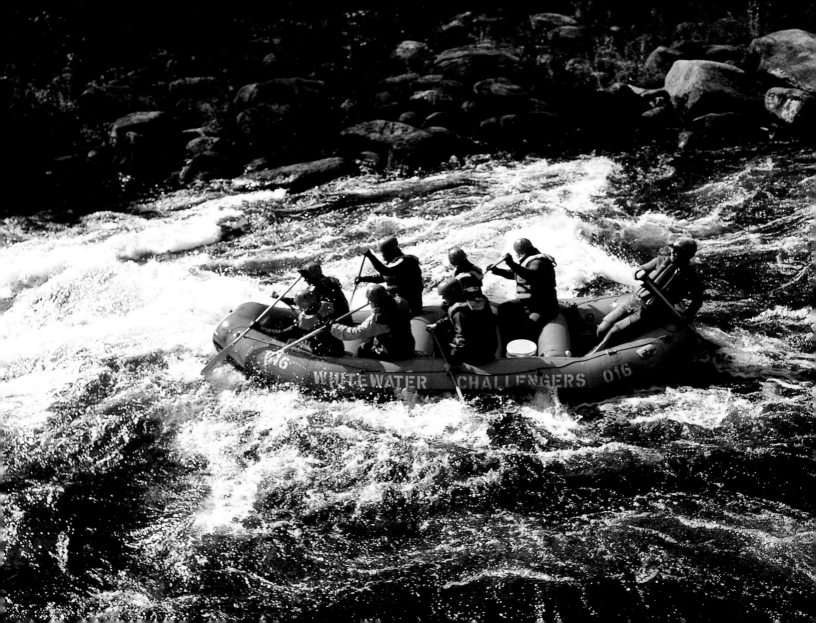

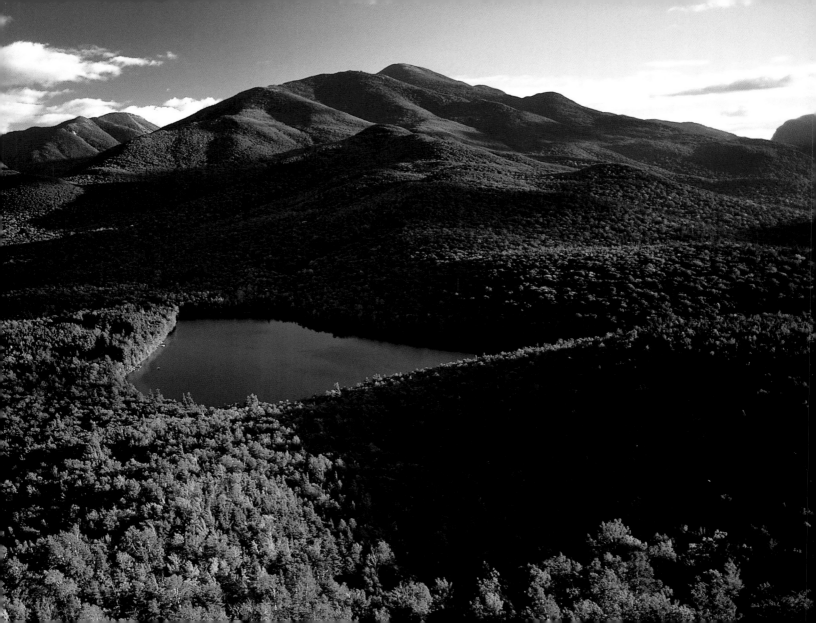

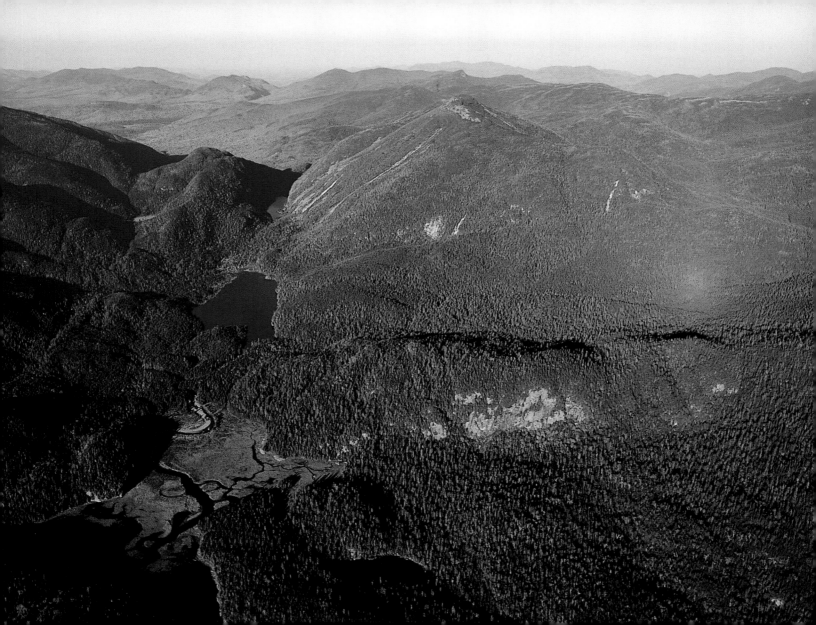

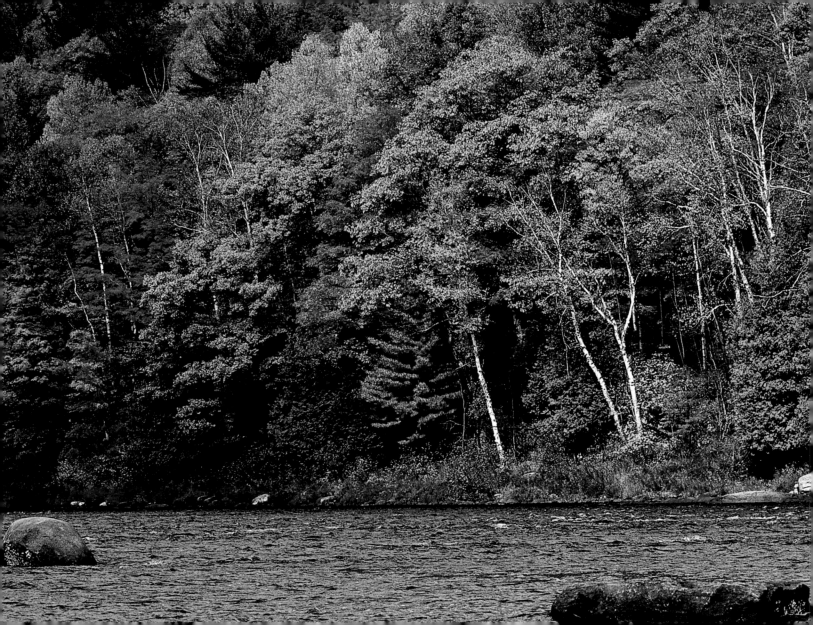

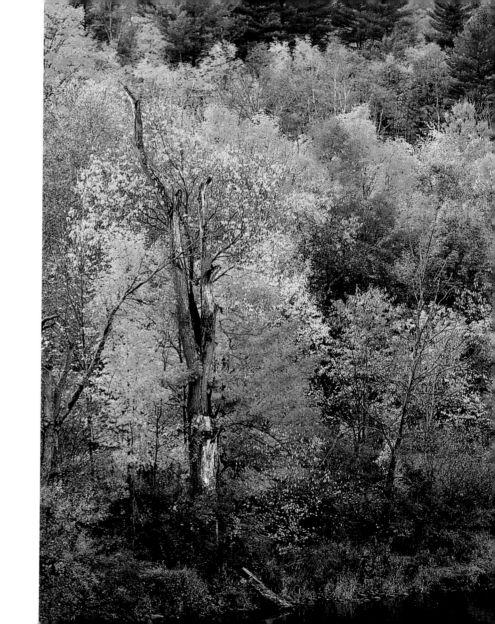

Right and opposite: North Creek, Adirondack Park.

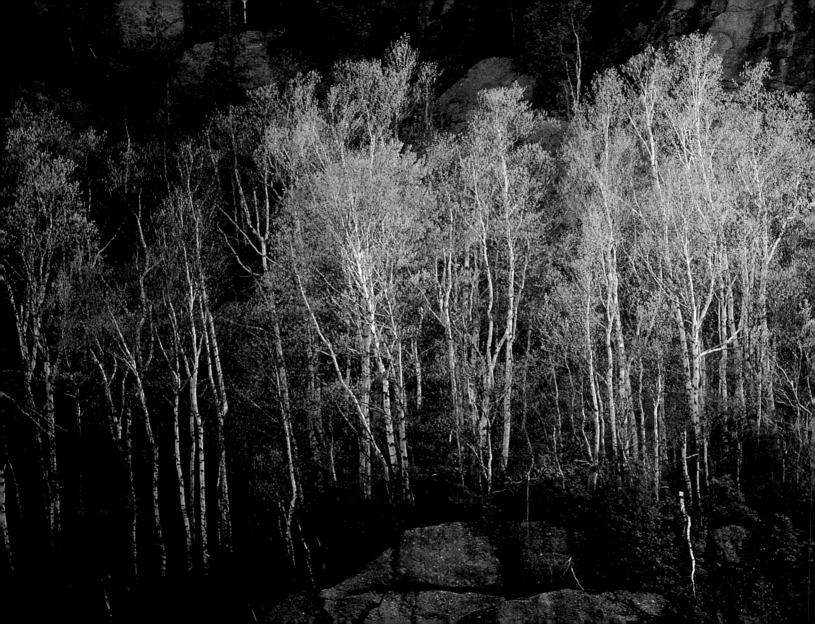

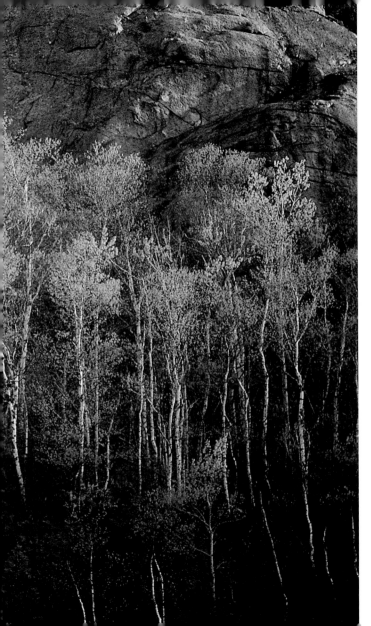

45

Chapel Lake, Adirondack Park.

Washbowl Lake, Adirondack Park.

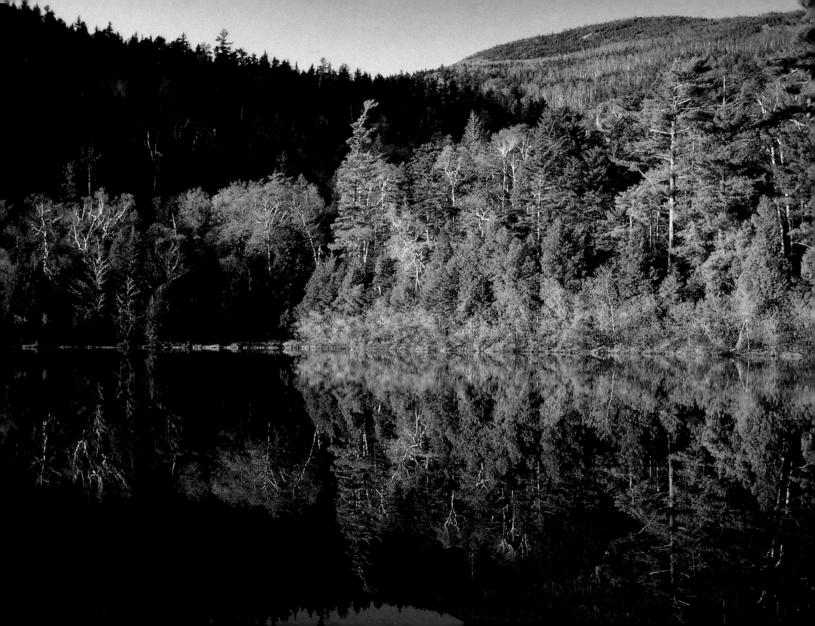

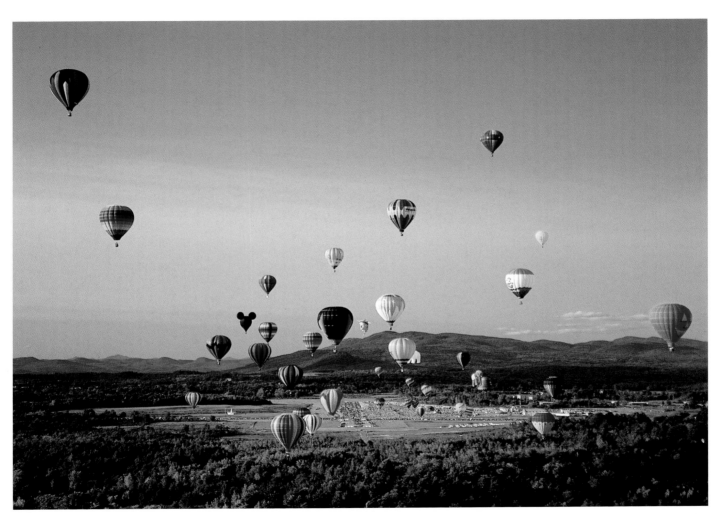

Adirondack Balloon Festival, Glen's Falls.

FROM THE SPOT WHERE we now stand—the turbulent Glen's Falls—to the sea, the banks of the beautiful river have voices innumerable for the ear of the patient listener; telling of joy and woe, of life and beauty, of noble heroism, and more noble fortitude, of glory, and high renown, worthy of the sweetest cadences of the minstrel, the glowing numbers of the poet, the deepest investigations of the philosopher, and the gravest records of the historian. Let us listen to those voices.

BENSON JOHN LOSSING, *The Hudson: From the Wilderness to the Sea, 1866*

THE MORNING BROKE with an unclouded sky, and before the dew was off the grass I was upon Bemis's Heights . . . A more beautiful view . . . I have seldom beheld. The ground there is higher than any in the vicinity, except the range of hills on the east side of the Hudson, and the eye takes in a varied landscape of a score of miles in almost every direction.

At the time of the revolution, the whole country in this vicinity was covered with a dense forest, having only an occasional clearing of a few acres; and deep ravines furrowed the land in various directions. Fronting the river, a high bluff of rocks and soil covered with stately oaks and maples, presented an excellent place on which to plant fortification to command the passage of the river and the narrow valley below. The bluff is still there, but the forest is gone and many of the smaller ravines have been filled up by the busy hand of cultivation.

BENSON JOHN LOSSING, *The Pictorial Field-Book of the Revolution, 1859*

Saratoga National Historic Park.

51

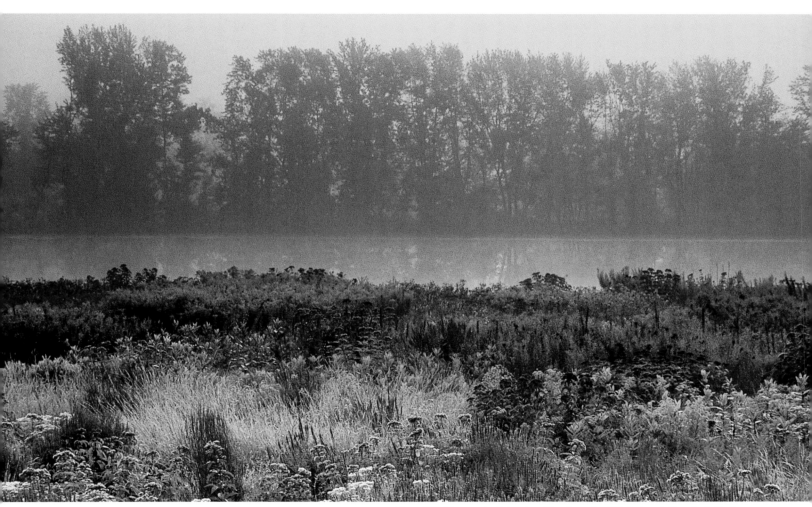

Above: Wildflowers in Schuylerville. *Opposite:* Elk Lake, Adirondack Park.

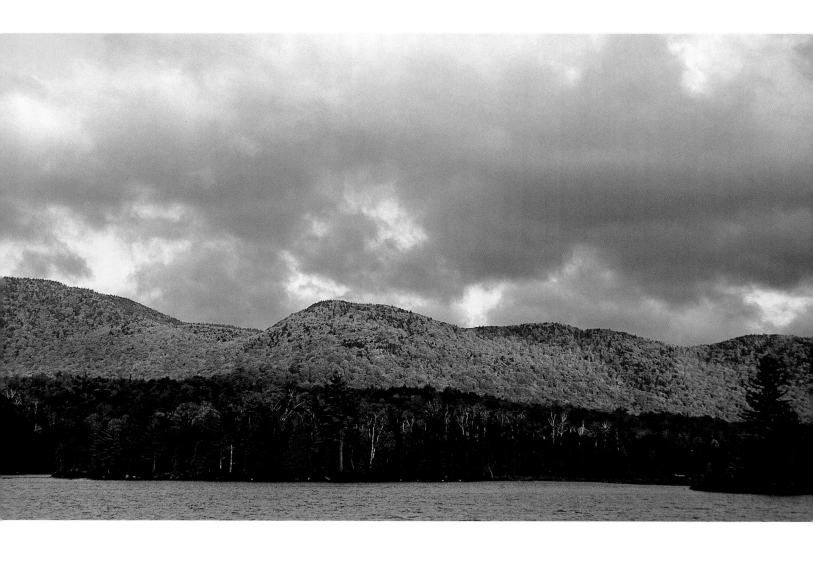

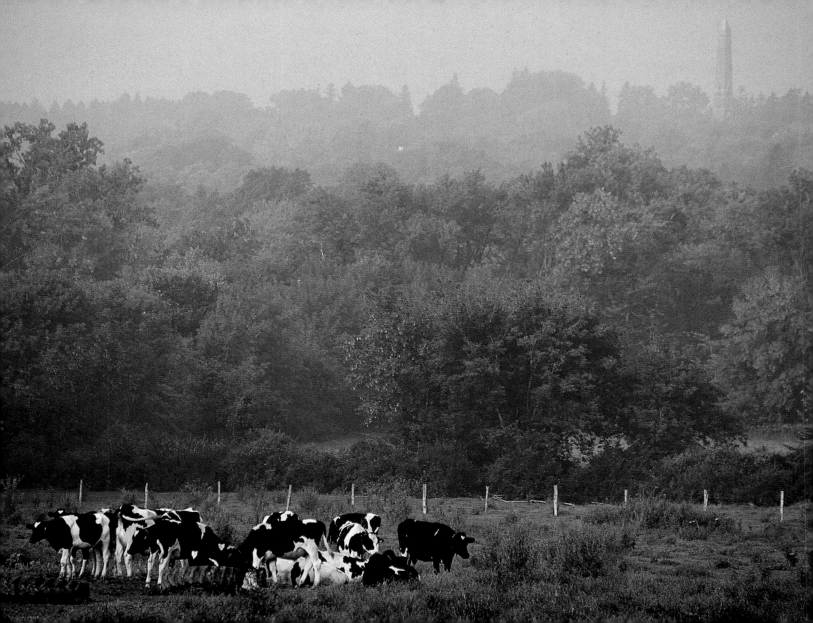

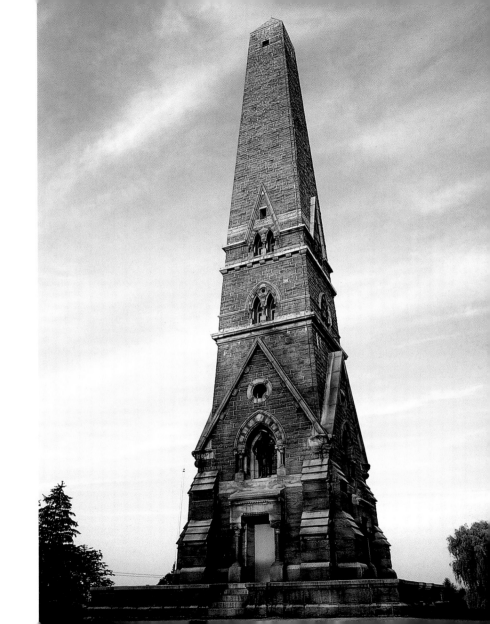

Right: Saratoga National Historic Monument.
Opposite: Cows in Washington County.

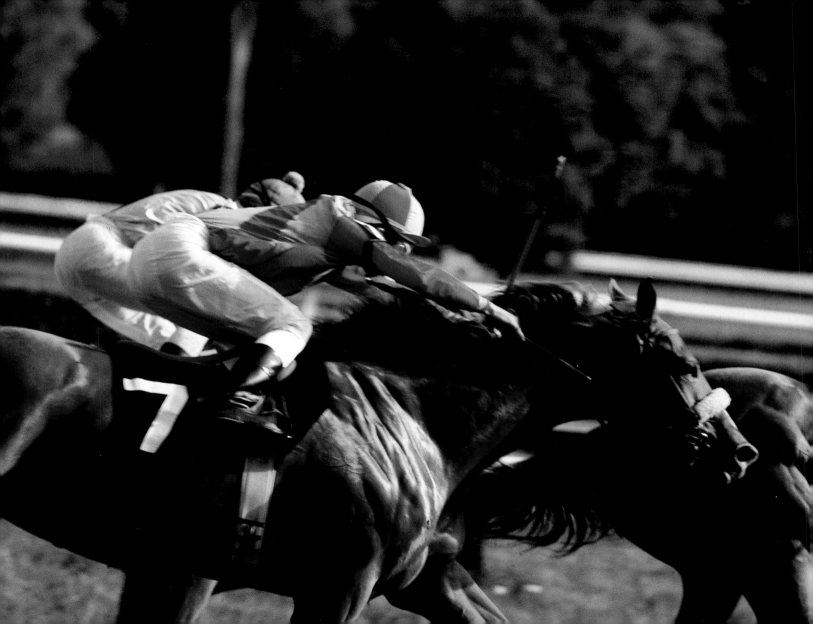

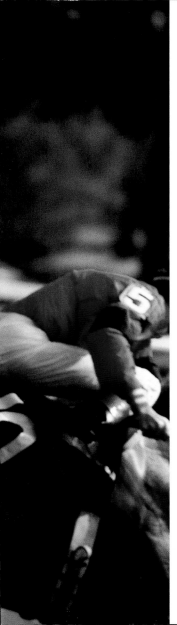

. . . passed the last half-mile, passed the last five in the field of seven, passed the favorite Oh Susanna, reached the post and kept steadily on . . .

EDNA FERBER, *Saratoga Trunk, 1941*

Saratoga racetrack.

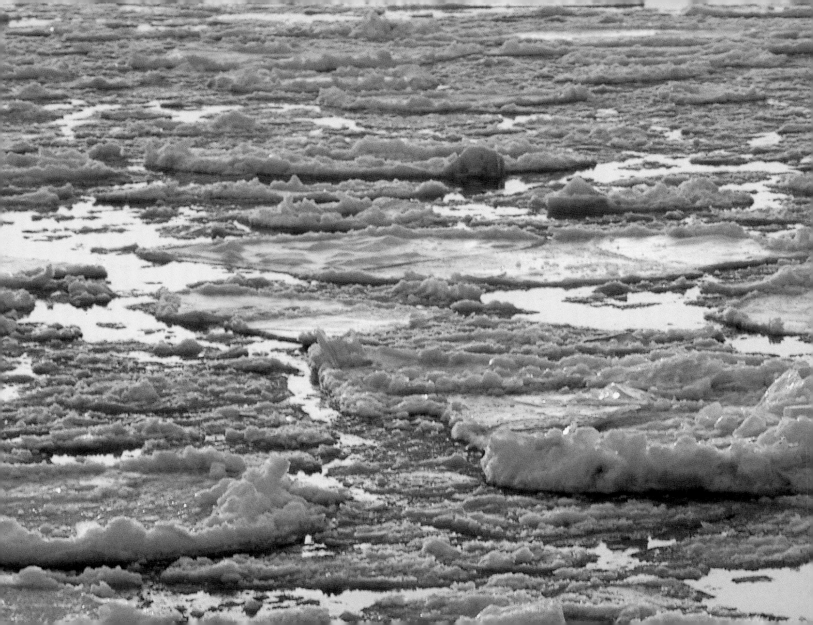

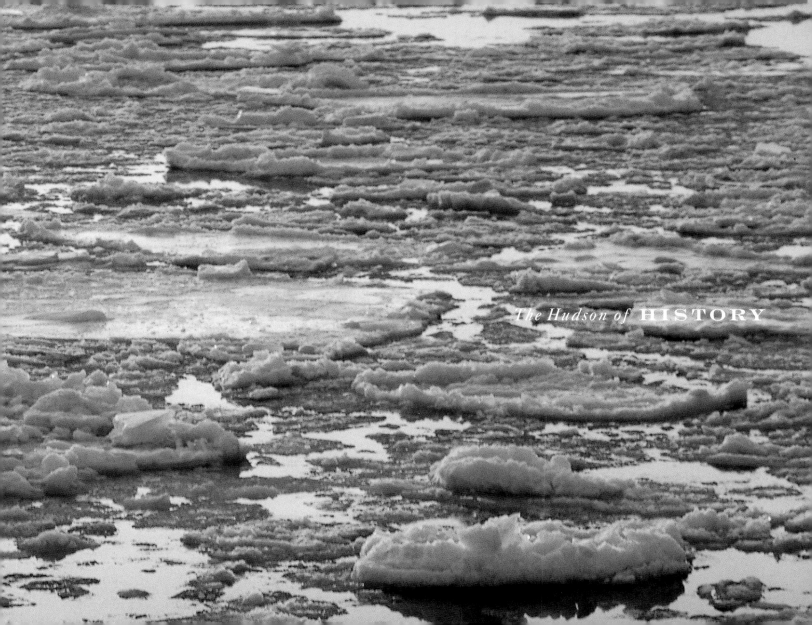
The Hudson of HISTORY

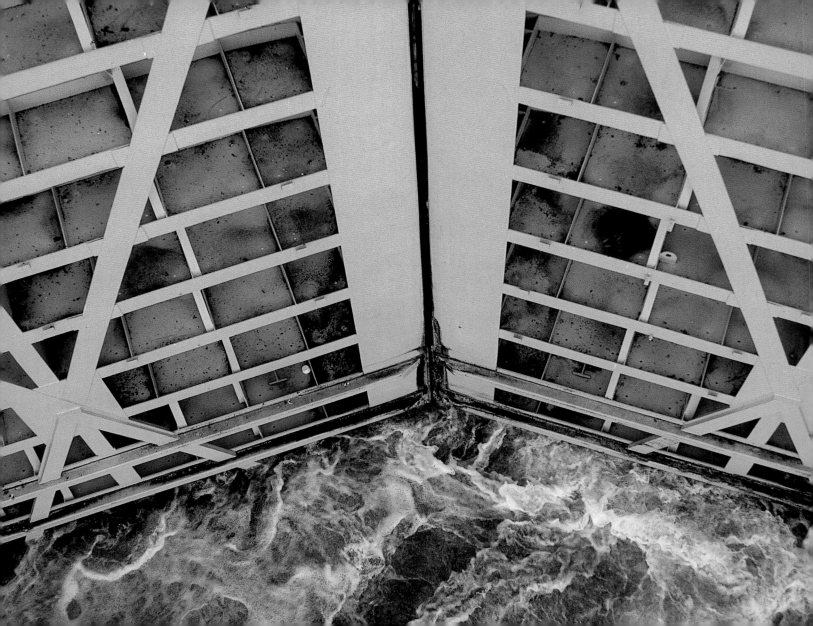

AS A BOND OF UNION between the Atlantic and western states, it may preserve the dismemberment of the American Empire. As an organ of communication between the Hudson, the Mississippi, the St. Lawrence, the Great Lakes of the north and west and their tributary rivers, it will create the greatest inland trade ever witnessed. The most fertile and extensive regions of America will avail themselves of its facilities for a market.

GOVERNOR DEWITT CLINTON

Erie Canal, Waterford.

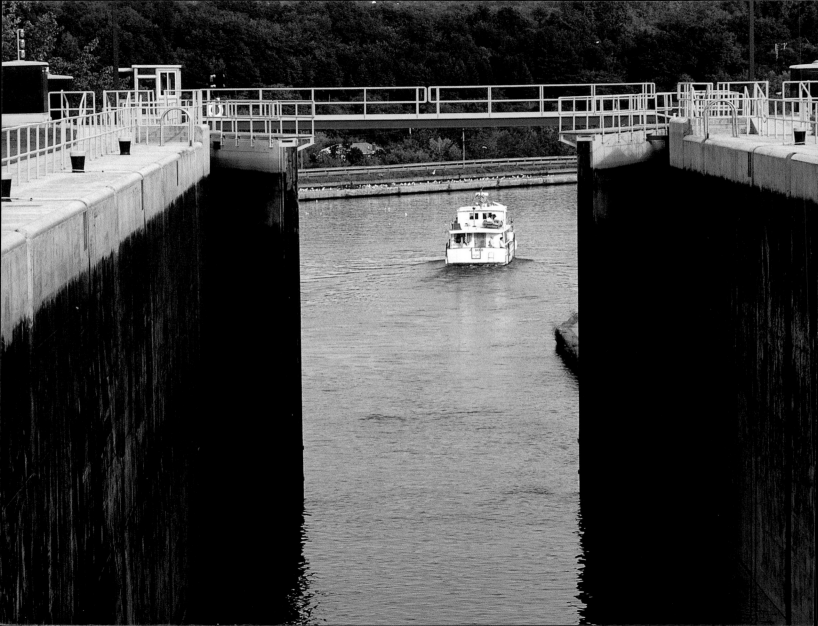

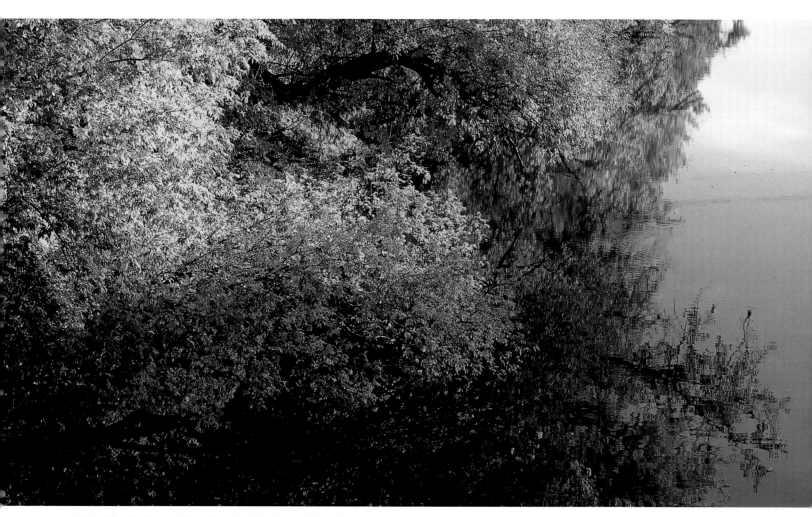

Above: Riverbank near Troy. *Opposite:* Erie Canal, Waterford.

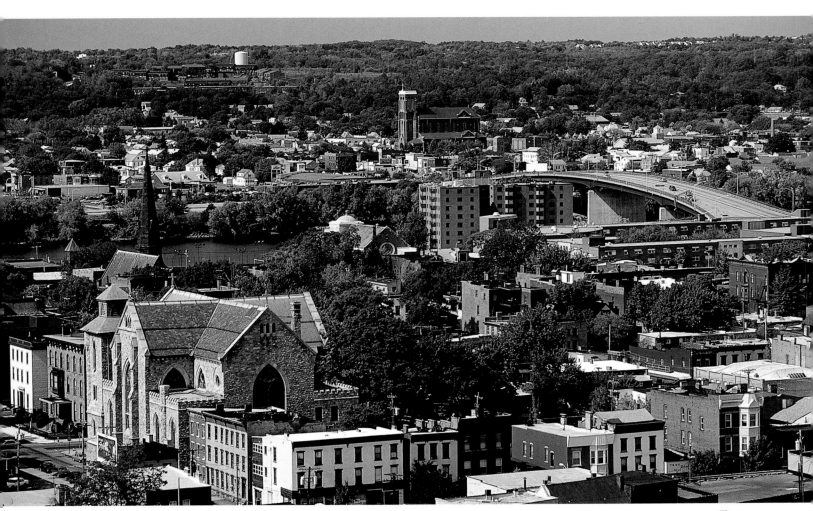

Troy.

TROY, THE CAPITAL OF RENSSELAER COUNTY, is six miles above Albany, and the head of the tide-water, one hundred and fifty-one miles from the city of New York. It is a port of entry, and its commerce is very extensive for an inland town. It is seated upon a plain between the foot of Mount Ida and the river. It has crept up the hill in some places, but very cautiously, because the earth is unstable, and serious avalanches have from time to time occurred. Its site was originally know as Ferry Hook, then Ashley's Ferry, and finally Vanderheyden, the name of the first proprietor of the soil on which Troy stands, after it was conveyed in fee from the Patroon of Rensslaerwyck, in the year 1720. After the Revolution the spot attracted some attention as an eligible village site. Town lots were laid out there in the summer of 1787, and two years afterward the freeholders of the embryo city, at a meeting in Albany, resolved that "in future it should be called and know by the name of Troy." At the same time, with the prescience of observing men, they said–"It may not be too sanguine to expect, at no very distant period, to see Troy as famous for her trade and navigation as may of our first towns."

BENSON JOHN LOSSING, *The Hudson: From the Wilderness to the Sea, 1866*

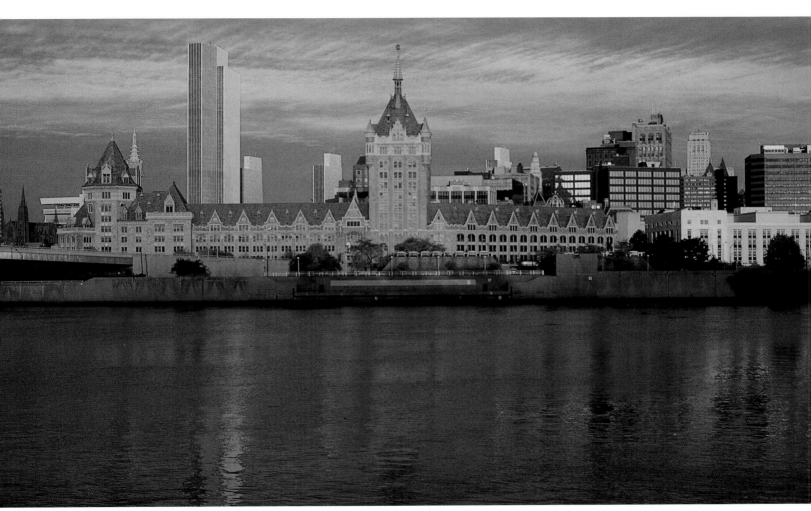

Above: Albany skyline with D & H Headquarters. *Opposite:* Albany.

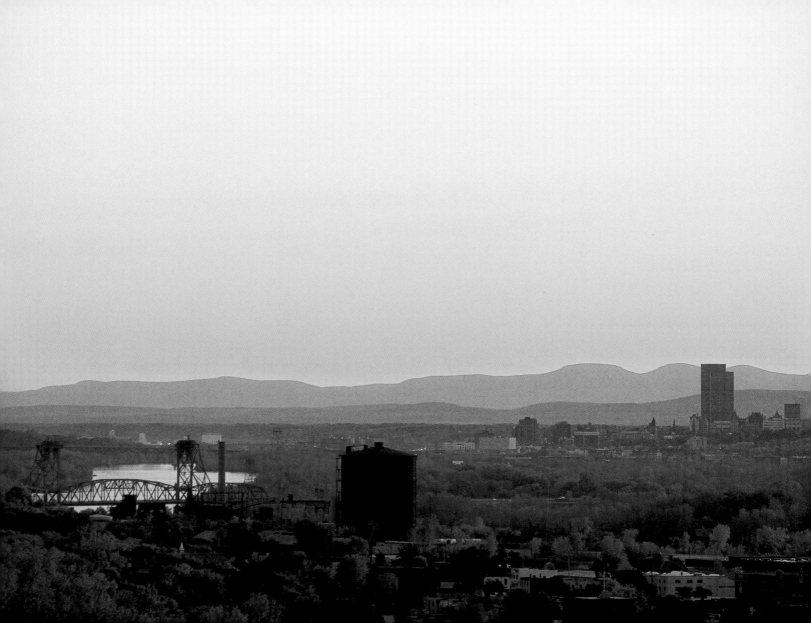

THE HISTORY OF ALBANY is not very definite, touching its first settlement. The probability seems, that, in 1614, the Dutch erected a fort and trading-house on an island just below the city; and also, in nine years after, a fort, which they called Fort Orange, on the present site. It would appear to have been canonically christened, and has been called at different periods Auralia, Beverwyck, and Williamstadt. "All this time," says the historian, "it was known also by the name of 'The Fuyck.'" The Indian appellation in which it rejoiced was Schau-naugh-ta-da, or Once the pine plains.

Albany is the residence of several of the oldest and wealthiest families in the State; but except this, it is a mere centre of transit—the channel through which passes the vast tide of commerce and travel to the north and west. The Erie and Champlain canals here meet the Hudson; and that which is passed up by this long arm from the sea, is handed over to the great lakes by the other two,—as if old Enceladus had been turned into a "wordy," and stood with his long arms between salt water and fresh.

NATHANIEL PARKER WILLIS, *American Scenery, 1836*

New York State Capitol and Governor Rockefeller Empire State Plaza, Albany.

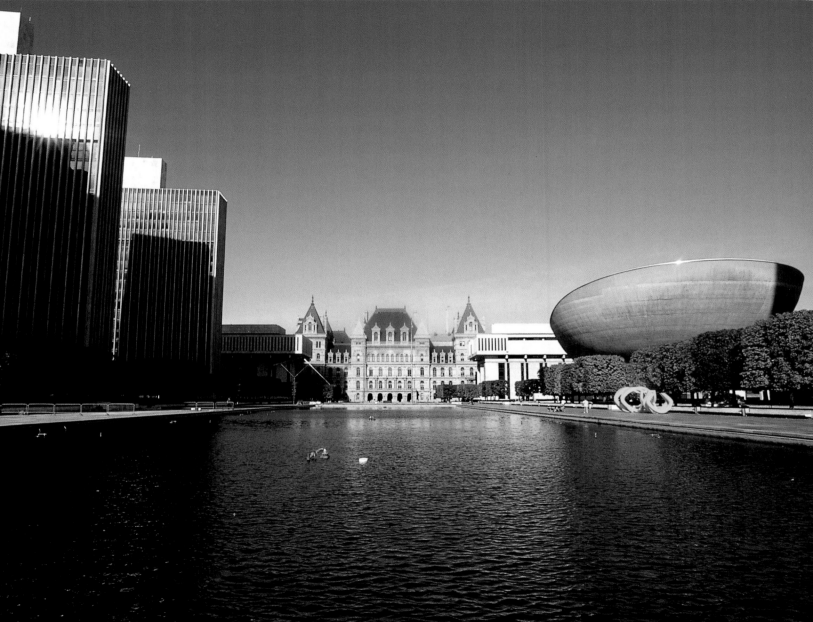

Above and opposite: Old Chatham.

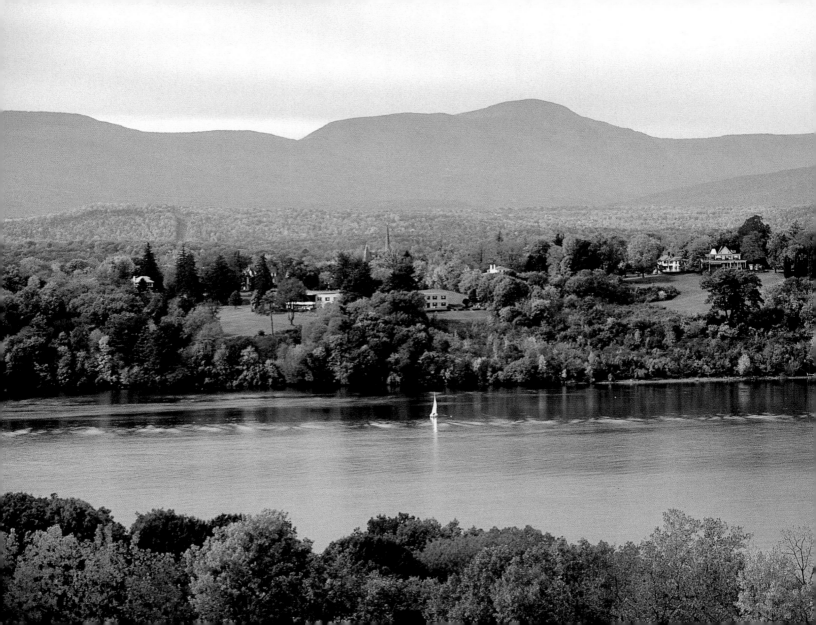

WHOEVER HAS MADE A VOYAGE up the Hudson must remember the Kaatskill Mountains. They are a dismembered branch of the great Appalachian family, and are seen away to the west of the river, swelling up to a noble height, and lording it over the surrounding country. Every change of season, every change of weather, indeed, every hour of day, produces some change in the magical hues and shapes of these mountains, and they are regarded by all the good wives, far and near, as perfect barometers. When the weather is fair and settled, they are clothed in blue and purple, and print their bold outlines on the clear evening sky; but, sometimes, when the rest of the landscape is cloudless, they will gather a hood of gray vapors about their summits, which, in the last rays of the setting sun, will glow and light up like a crown of glory.

WASHINGTON IRVING, *Autobiography, 1909*

The Catskills from Hudson.

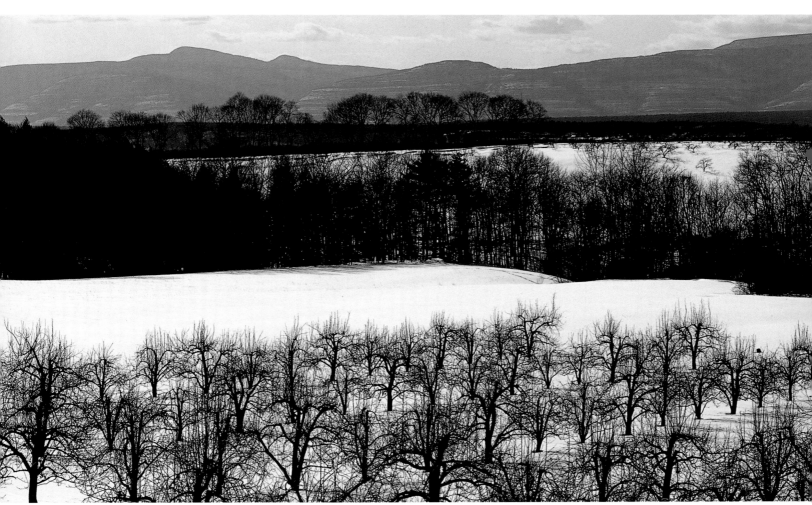

Above and opposite: Apple orchards in Hudson.

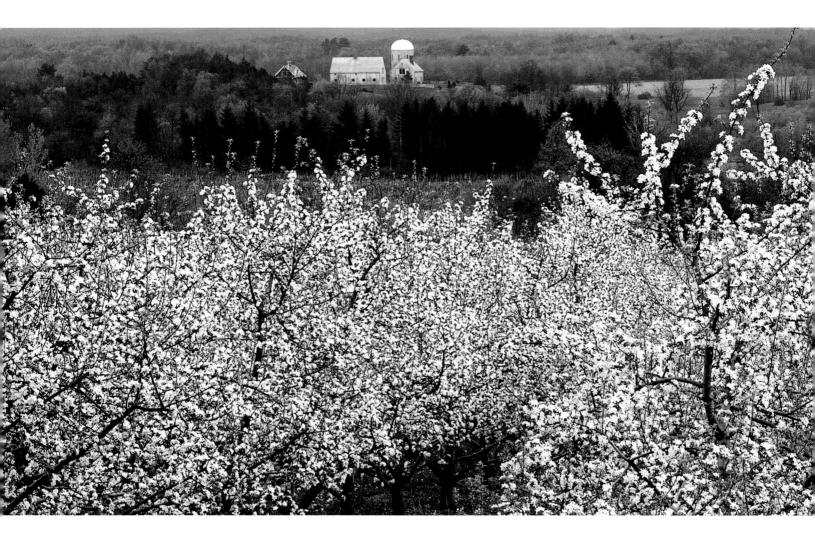

HUDSON (115 miles from New York; population 9,633), was founded in the year 1784, by thirty persons from Providence, R. I., and incorporated as a city in 1785. The city is situated on a sloping promontory, bounded by the North and South Bays. Its main streets, Warren, Union and Allen, run east and west a little more than a mile in length, crossed by Front Street, First, Second, Third, etc. Main Street reaches from Promenade Park to Prospect Hill. The Park is on the bluff just above the steamboat landing; we believe this city is the only one on the Hudson that has a promenade ground overlooking the river. It commands a fine view of the Catskill Mountains, Mount Merino, and miles of river scenery . . .

Hudson grew more rapidly than any other town in America except Baltimore. Standing at the head of a ship navigation it would naturally have become a great port had it not been for the steam engine and steamboat.

WALLACE BRUCE, *The Hudson, 1901*

Warren Street, Hudson.

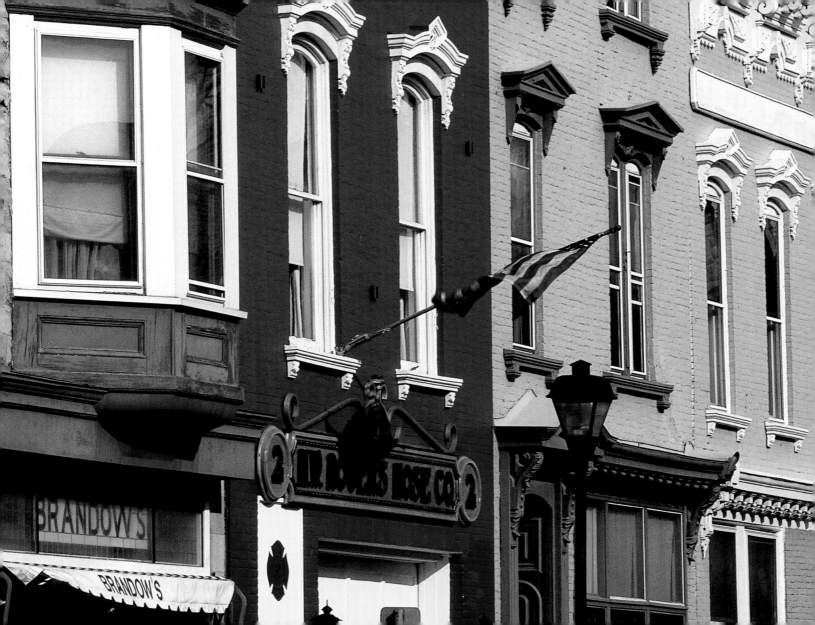

FREDERIC EDWIN CHURCH, born at Hartford, Connecticut, was the son of a wealthy man whose considerable assets provided the youth with the means to develop his early interest in art. By the age of sixteen, he was studying drawing and painting; two years later, Daniel Wadsworth, son-in-law of John Trumbull and, like Trumbull, a patron of Thomas Cole's, prevailed upon Cole to take Church as his pupil. Church's precociousness displayed itself quickly . . .

In 1860 Church bought farmland at Hudson, New York, and married Isabel Carnes, whom he met during the exhibition of his Heat of the Andes. His marriage to both—his wife and his farm—became the joint center of his life, in later years tending to divert his attentions from painting major canvases. Church's happiness was blasted in March of 1865, when his son and daughter died of diphtheria, but with the birth of Frederic junior in 1866, Church and his wife began a new family that was eventually

Olana State Historic Site, Hudson.

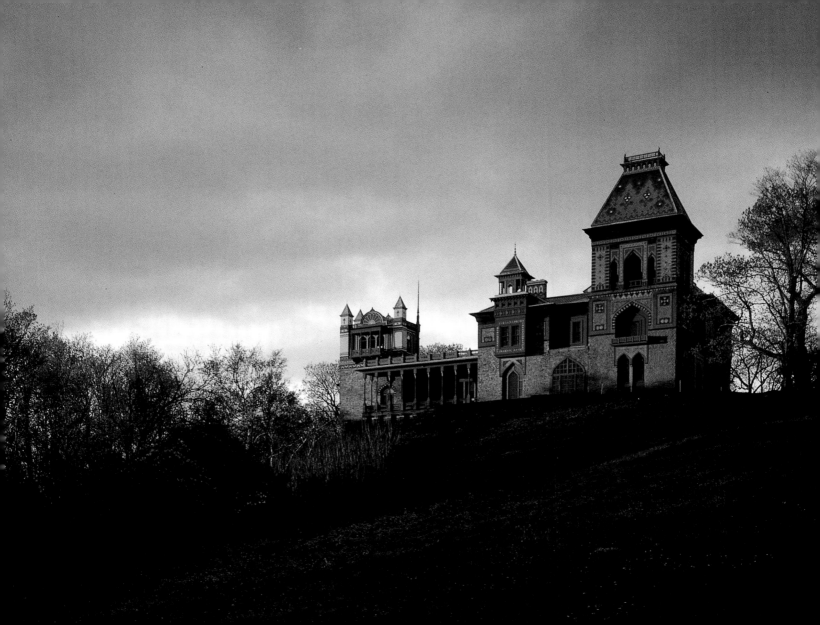

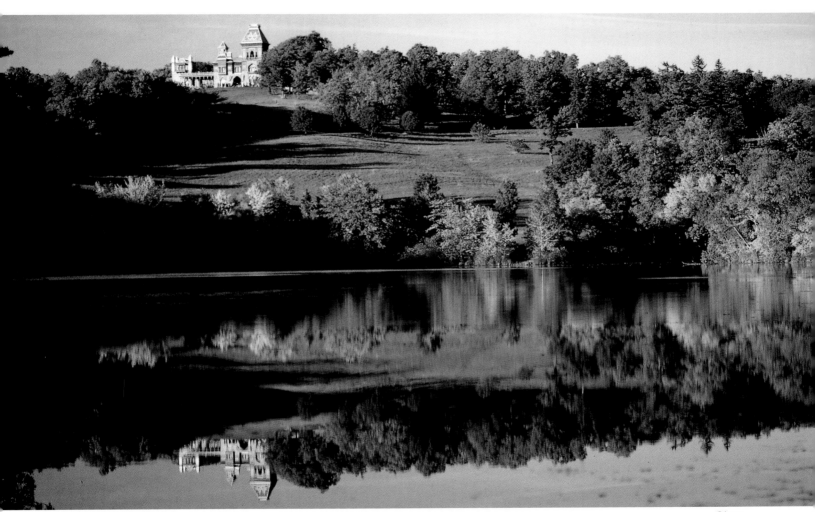

Olana.

to number four children. In late 1867, the Churches launched on an eighteen-month trip to Europe, North Africa, the Near East, and Greece that was the genesis of several important pictures. Church, however, began to devote his creative energies increasingly to gentleman farming and to the designing and redesigning of Olana, his hilltop fantasy of a Persian villa at Hudson, New York, a seemingly endless undertaking began in 1869 in consultation with the architect Calvert Vaux. From the 1870s until his death afflicted with painful rheumatism of the right arm, which interrupted or prevented work on major pictures, Church still managed to produce in his later years a few retrospective canvases. His final artistic legacy was a multitude of breathtaking small oil sketches, mostly of Olana.

JOHN K. HOWAT, *American Paradise: The World of the Hudson River School, 1987*

Fishing in the Hudson, Catskill.

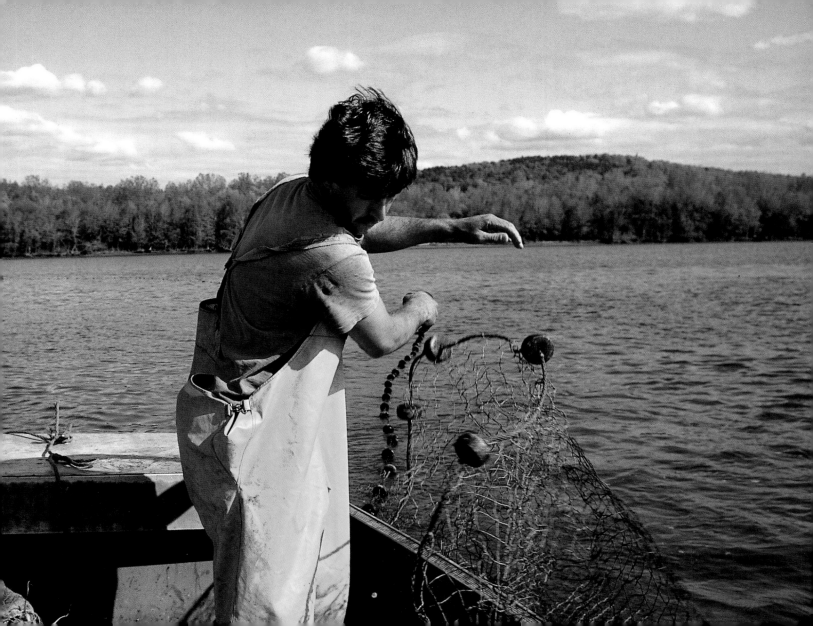

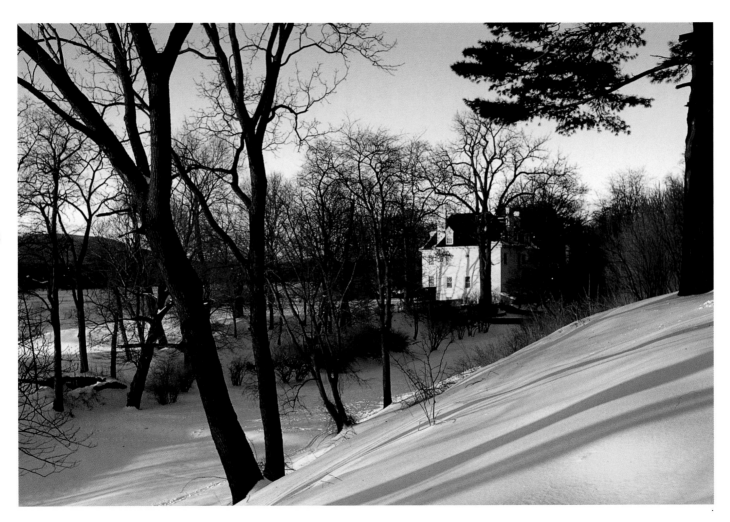

CLERMONT, the mansion Livingston had built for himself in 1793, stood high on a natural terrace looking across the broad Hudson River Valley to the timeworn Catskill Mountains, their rounded peaks silvery at that season with encrustations of ice and snow. The design of the house was highly personal. Extending from the two-story central section were four one-story pavilions—in plan like an H with the 104-foot-long sides squarely facing the river and the mountains beyond. Built of brick and local stone and covered with stucco, the most striking feature was the great multi-paned windows, which gave the exterior the airy elegance of a small French chateau and admitted to the interior abundant light. Much of the furniture and wallpaper was imported from France. The library, of which Livingston was justly proud, contained over four thousand volumes. The greenhouse, with adjoining bathing rooms and offices that he had just added to the south wing, was innovative and pleasant.

CYNTHIA OWEN PHILIP, *Robert Fulton: A Biography, 1985*

Clermont State Historic Site, Germantown.

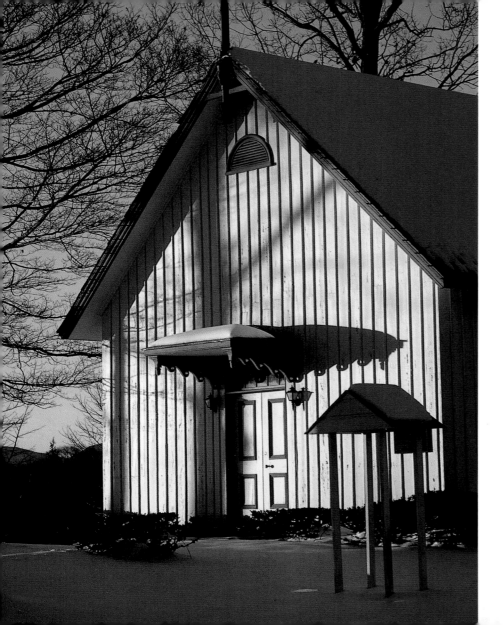

Left and opposite: Clermont.

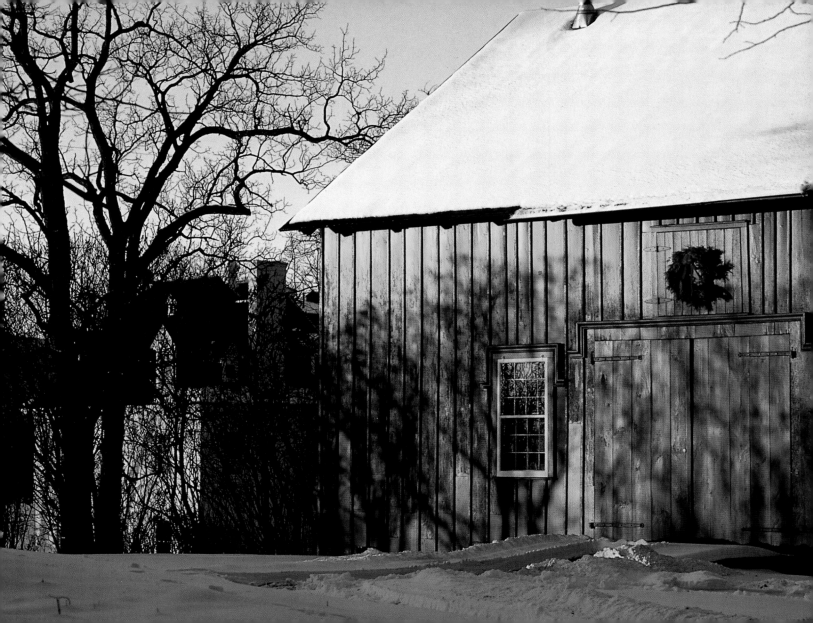

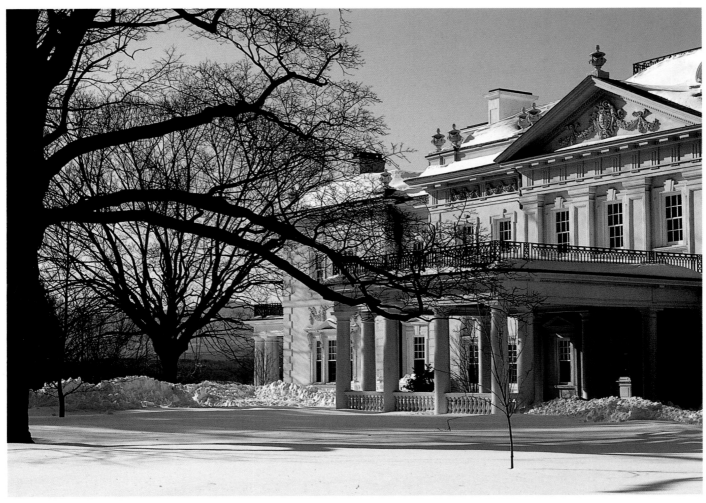

88

Above and opposite: Blithewood, Bard College, Annandale.

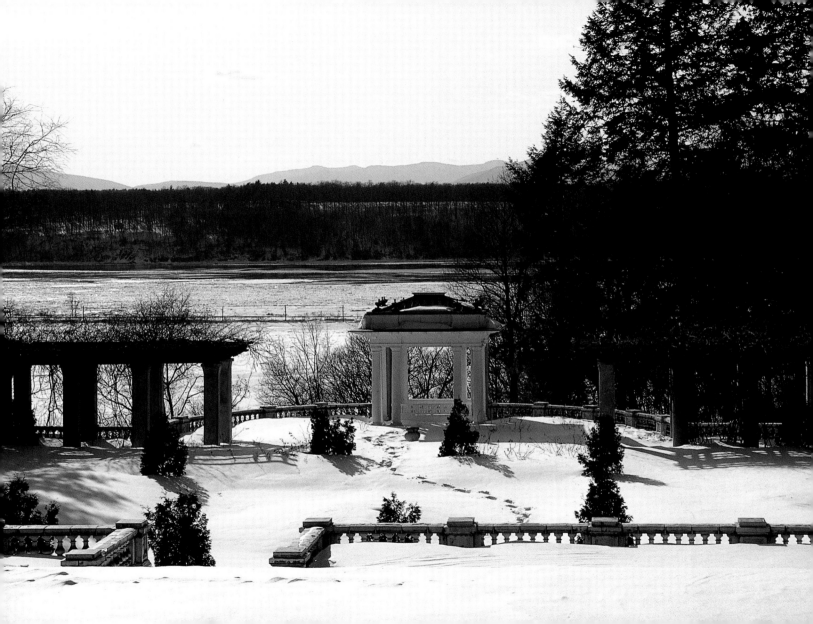

90

Fisher Center for the Performing Arts, Bard College.

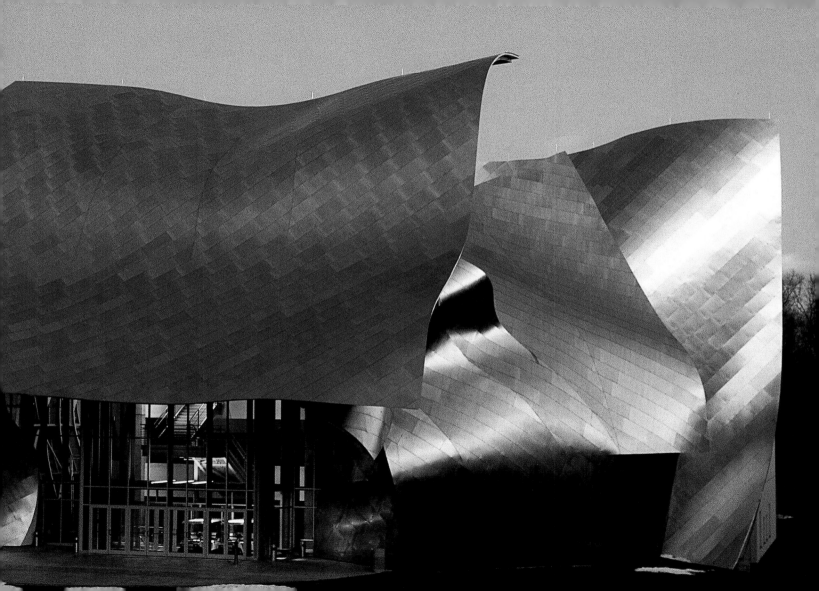

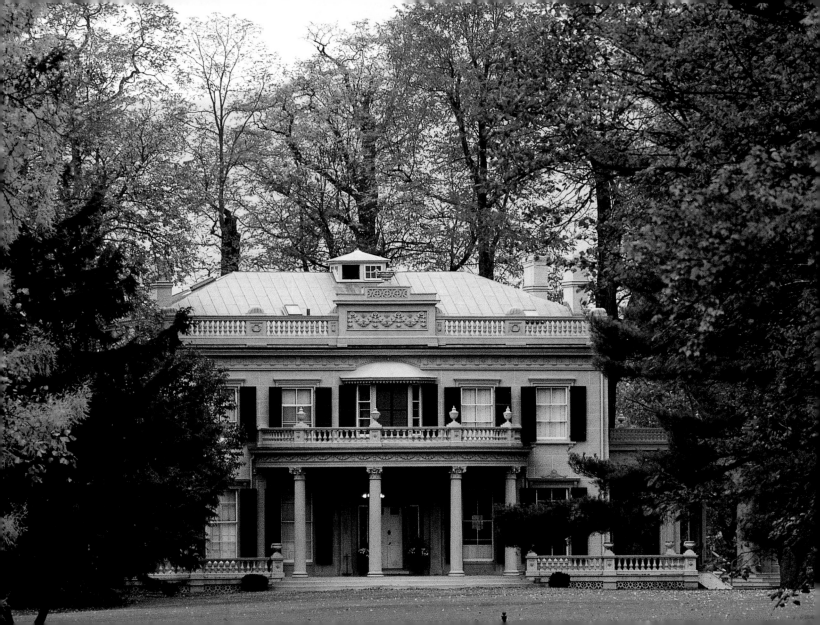

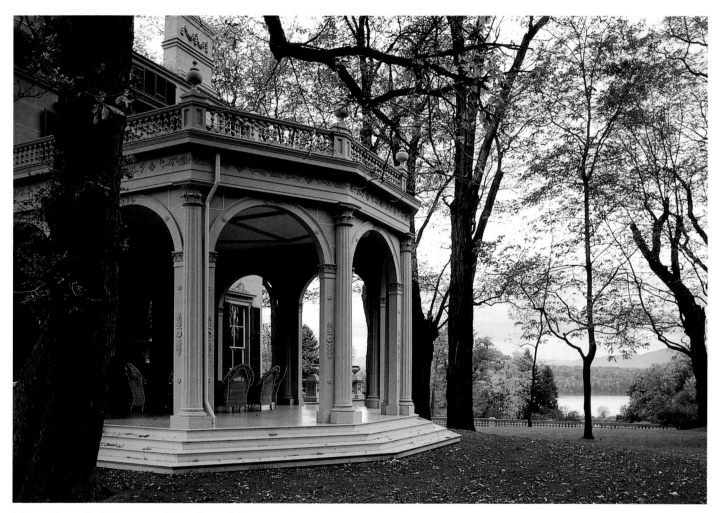

93

Above and opposite: Montgomery Place, Annandale.

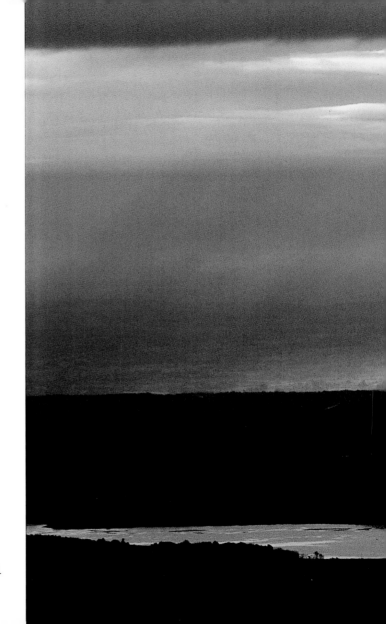

94

Right: Hudson River Valley from Escarpment Trail.

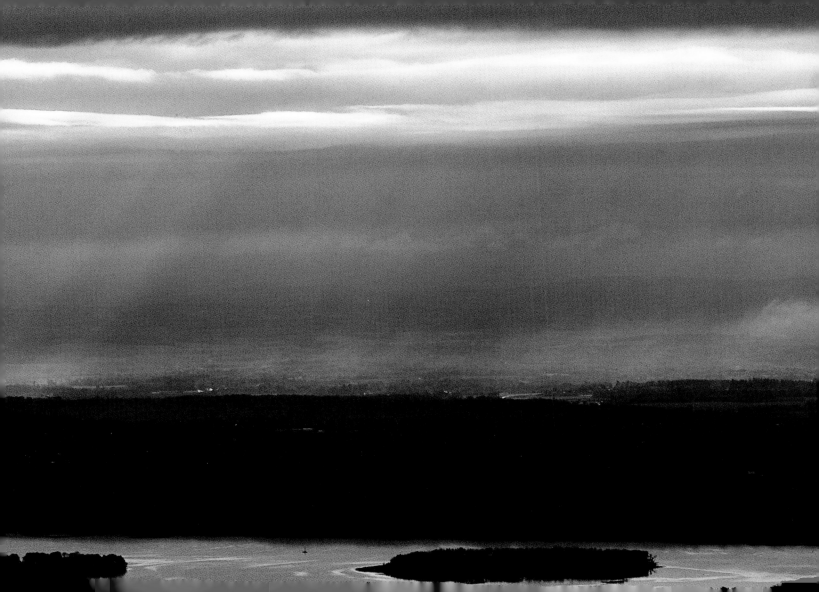

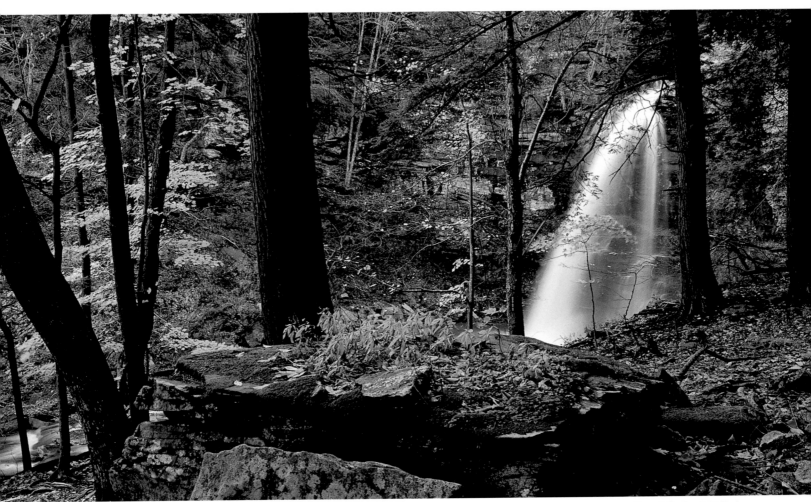

Platte Cove Waterfall, Catskill Park.

"Why, there's a fall in the hills where the water of the two little ponds, that lie near each other, breaks out of their bounds and runs over the rocks into the valley . . . The water comes crooking and winding among the rocks; first so slow that a trout could swim in it, and then starting and running like a creatur' that wanted to make a far spring, till it gets to where the mountain divides, like the cleft hoof of a deer, leaving a deep hollow for the brook to tumble into . . . The stream gathers itself together again for a new start, and maybe flutters over fifty feet of flat rock before it falls another hundred, when it jumps about from shelf to shelf, first turning thisaway and then turning thataway, striving to get out of the hollow, till it finally comes to the plain."

JAMES FENIMORE COOPER, Natty Bumpo in *The Pioneers, 1823*

AN EARLY COMMENT on the vegetation of the area is found in Henry Hudson's Journal in an entry made in 1609 at a point twelve days sail up the Hudson River, "We rode still and went on land to walke of the west side of the River, and found goode grounde for corn and other garden herbs, with great store of goodly oakes and walnut-trees and Chestnut trees, ewe trees and trees of sweetwood in great abundance."

ROBERT P. MCINTOSH, *The Forest of the Catskill Mountain Region, New York, As Indicated by Land Survey Records, 1962*

Platte Cove Waterfall, Catskill Park.

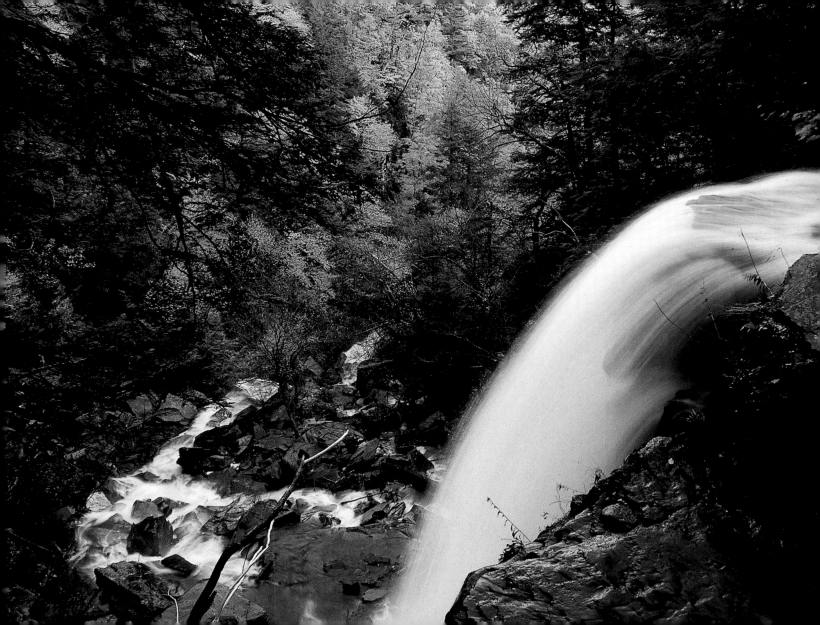

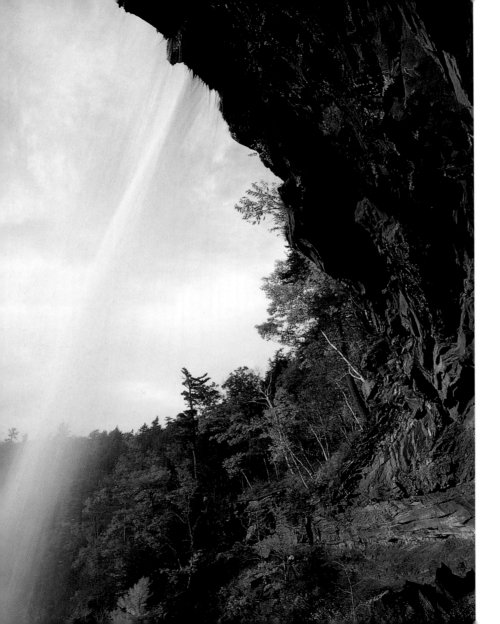

Kaaterskill Falls, Catskill Park.

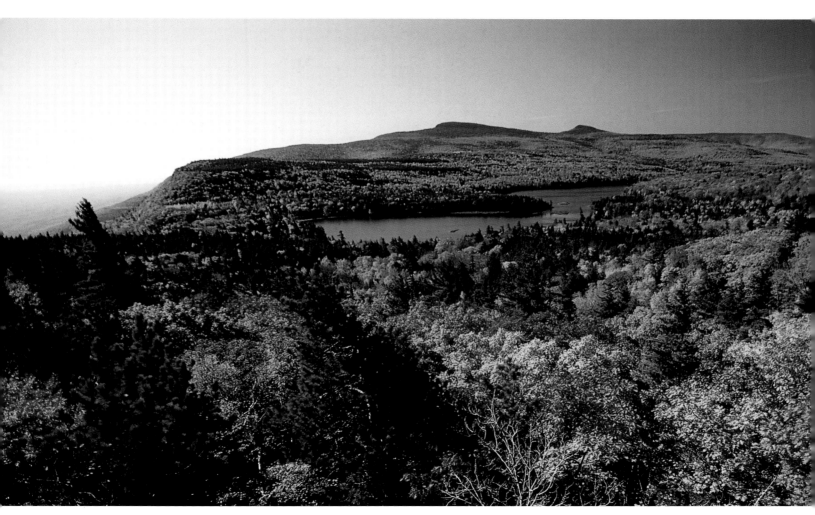

North and South Lakes from Sunset Point, Catskill Park.

102

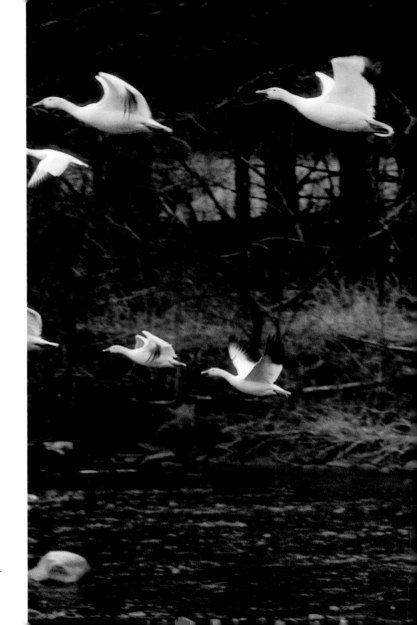

Snowgeese, Catskill Park.

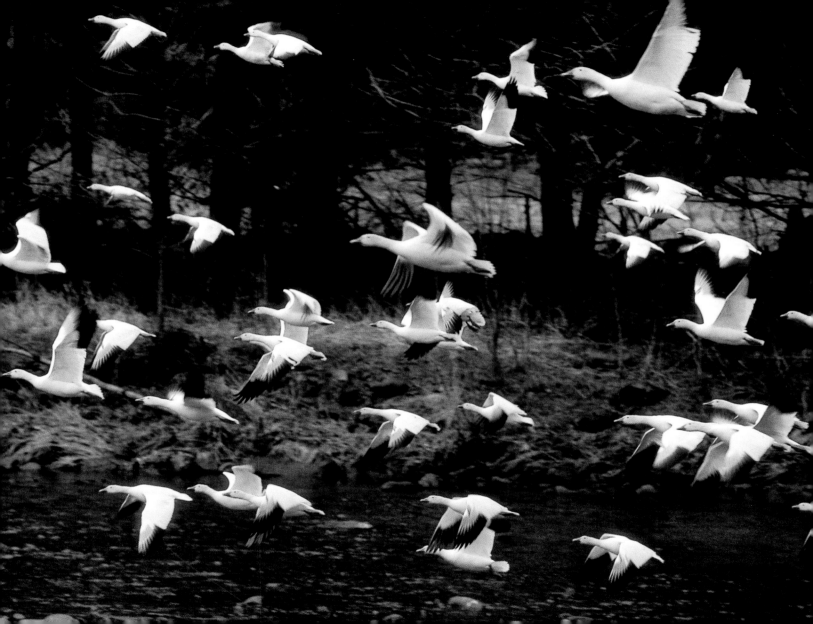

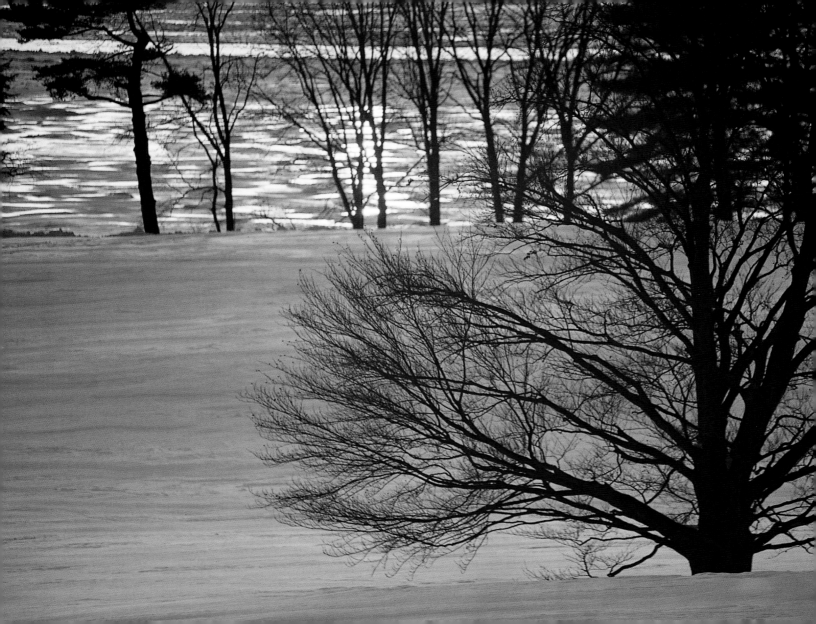

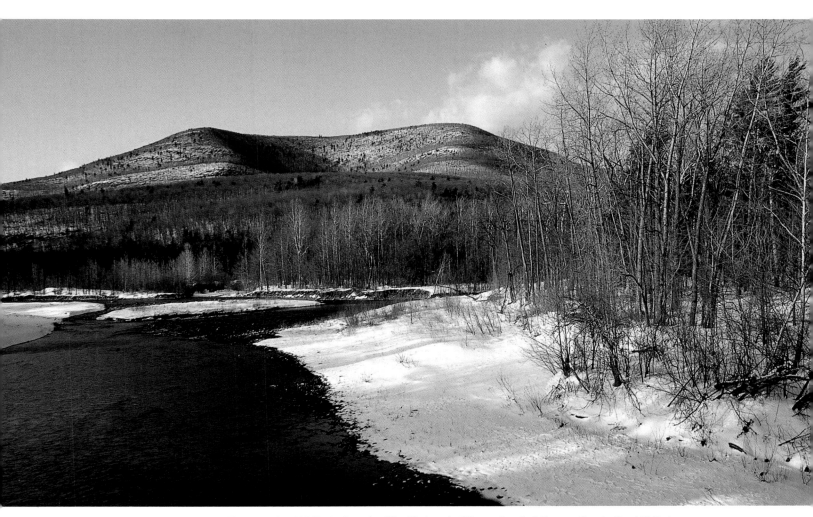

Above: Esopus Creek and Mount Tremper, Catskill Park. *Opposite:* The Hudson in Winter. *Overleaf:* Esopus Creek, Catskill Park.

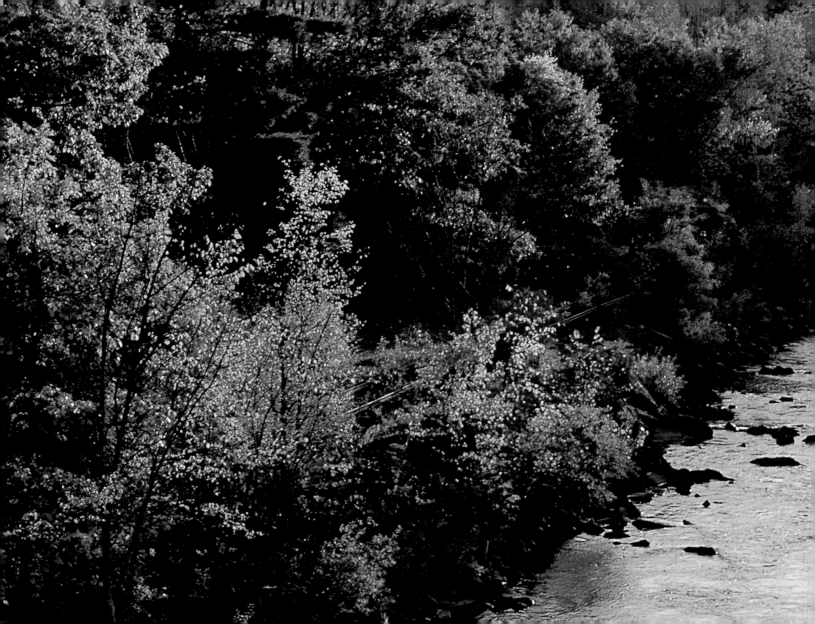

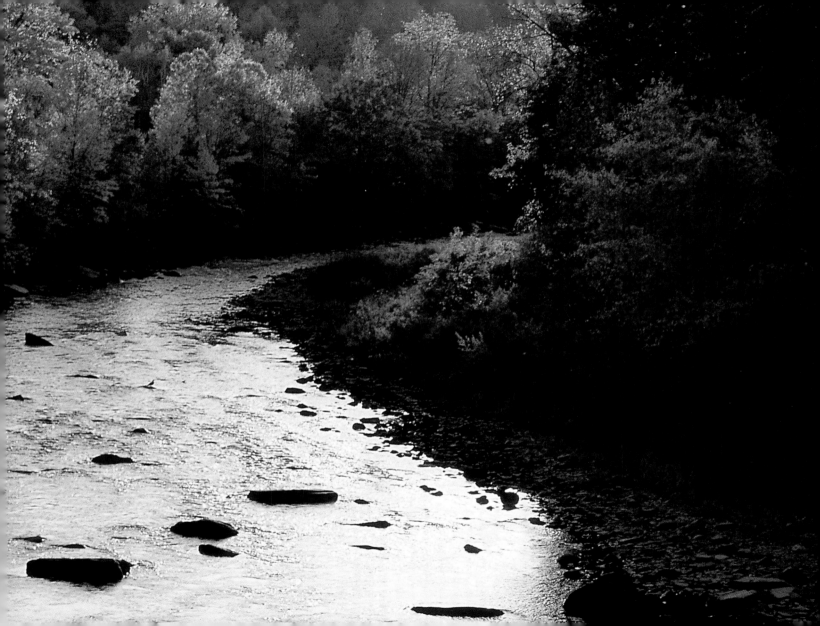

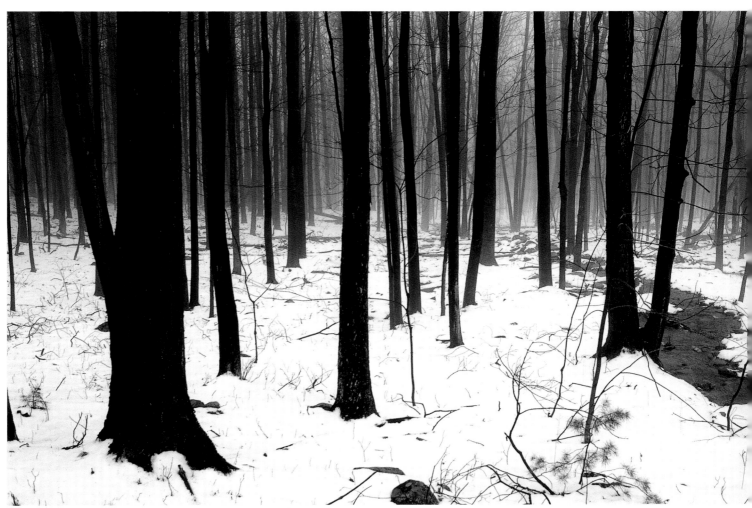

Left and opposite: Trees around Ashokan Reservoir, Catskill Park.
Overleaf: Road to Mount Tremper, Catskill Park.

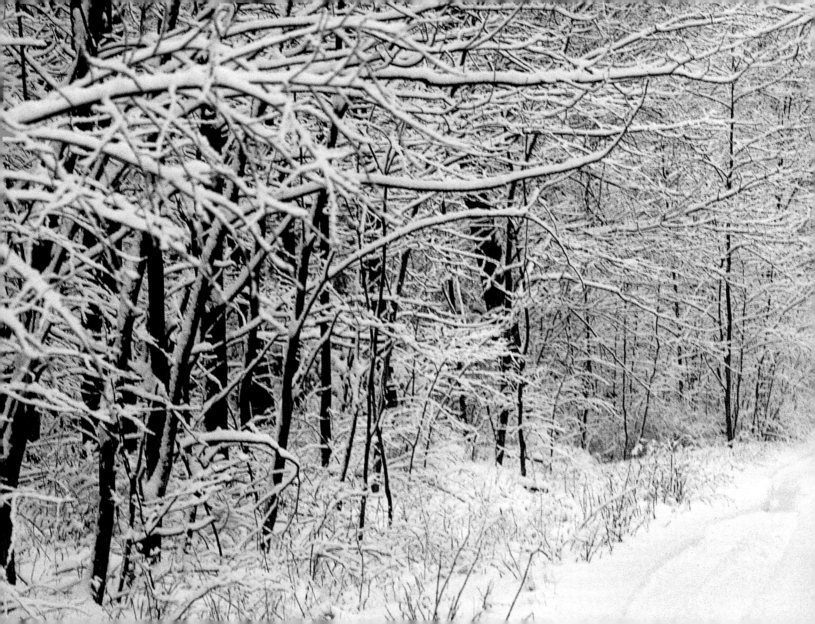

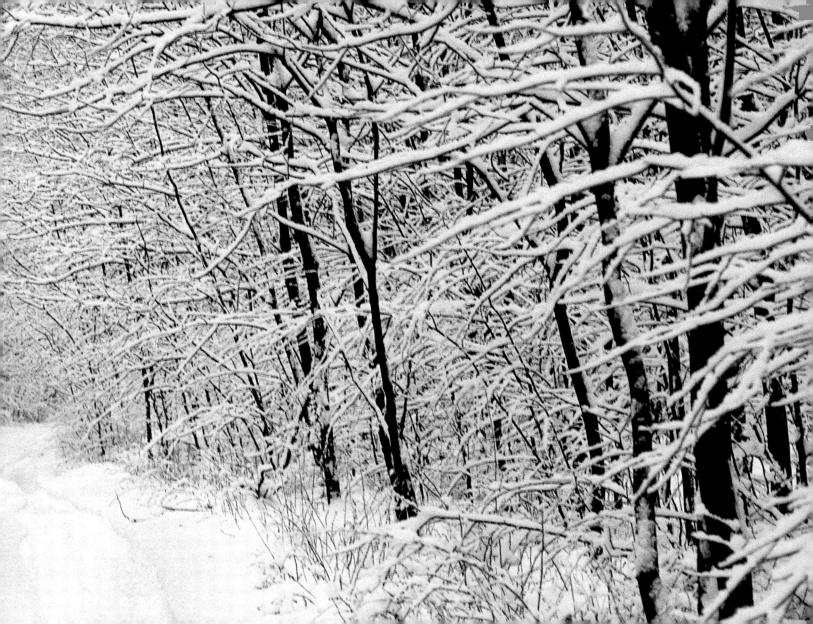

LOOK UP AT THE MIRACLE of the falling snow,—the air a dizzy maze of whirling, eddying flakes, noiselessly transforming the world, the exquisite crystals dropping in ditch and gutter, and disguising in the same suit of spotless livery all objects upon which they fall. How novel and fine the first drifts! The old dilapidated fence is suddenly set off with the most fantastic ruffles, scalloped and fluted after an unheard-of fashion! Looking down a long line of decrepit stone wall, in the trimming of which the wind had fairly run riot, I saw, as for the first time, what a severe yet master artist old Winter is. Ah, a severe artist! How stern the woods look, dark and cold and as rigid against the horizon as iron!

JOHN BURROUGHS, "The Snow Walkers," *In the Catskills*

Kingston.
Overleaf: View from the Mills Mansion, Staatsburg.

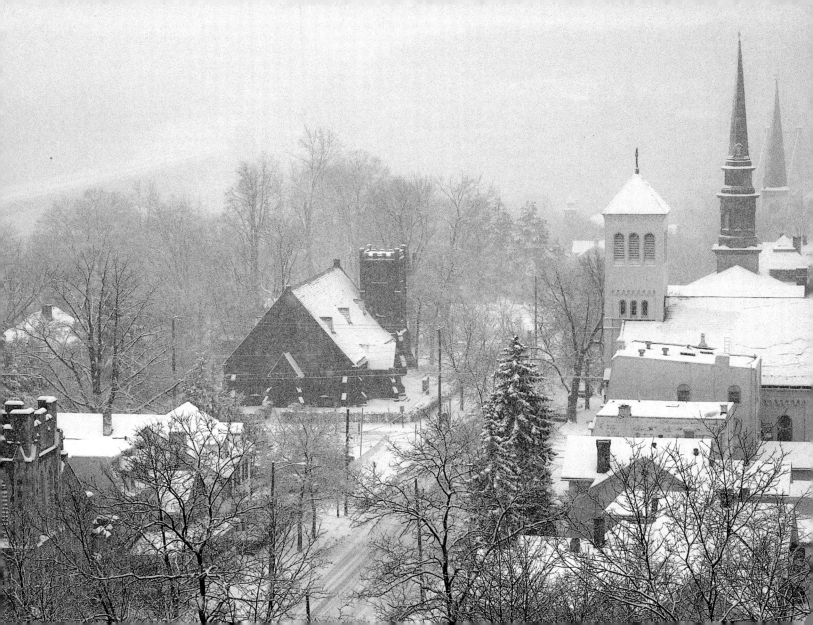

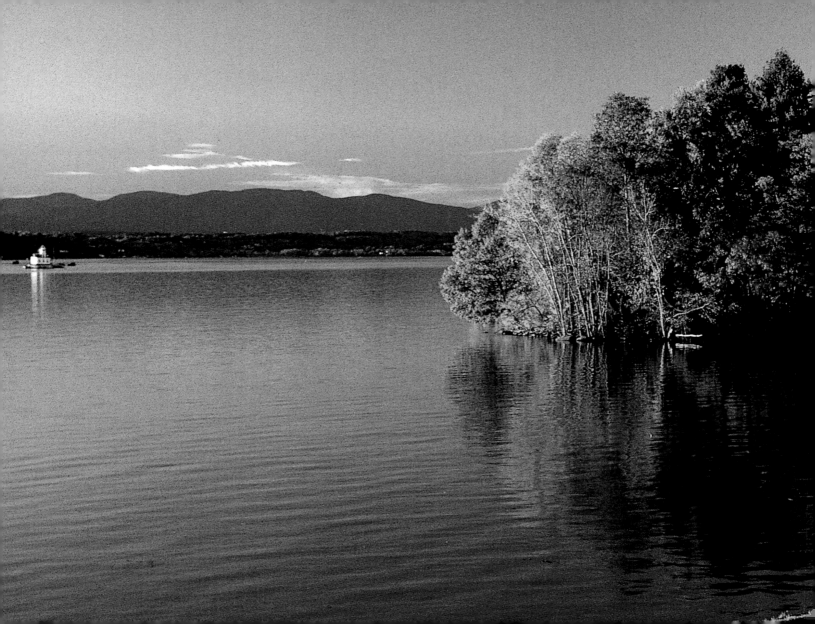

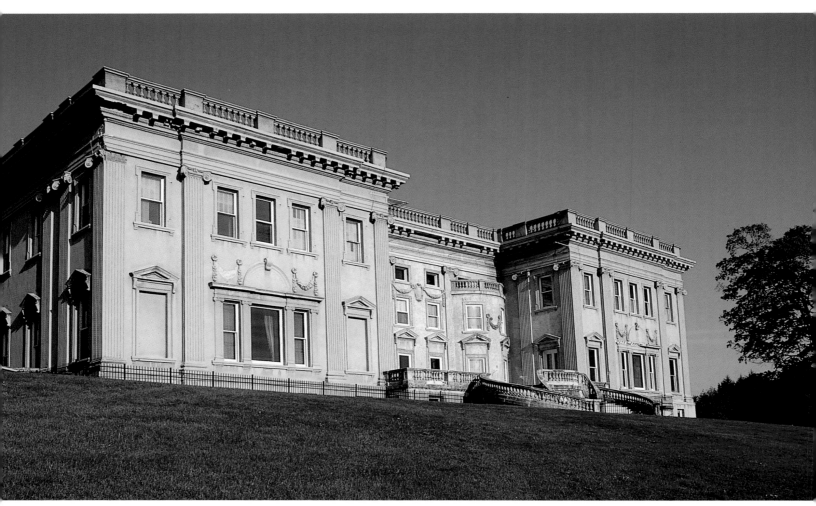

Mills Mansion.

WHEN THE ORIGINAL MANSION BURNED in 1832, Morgan Lewis and his wife immediately had it rebuilt in the popular Greek Revival style of their day. At the end of the 19th Century, the home was in the possession of Ruth Livingston Mills, great-granddaughter of the original builder and wife of Ogden Mills, a wealthy financier and philanthropist. At the time the old Greek Revival building was heavily remodeled in accordance with designs prepared by the prestigious architectural firm of McKim, Mead & White. Two large wings were added to the existing central core and the exterior was embellished with balustrades, pilasters and swags. The interior, decorated in the style of Louis XV and Louis XVI, remains rich with marble fire-places, oak paneling, and gilded ceiling and wall decorations installed at that time.

MILLS MANSION STATE HISTORIC SITE BROCHURE

Kingston Lighthouse.

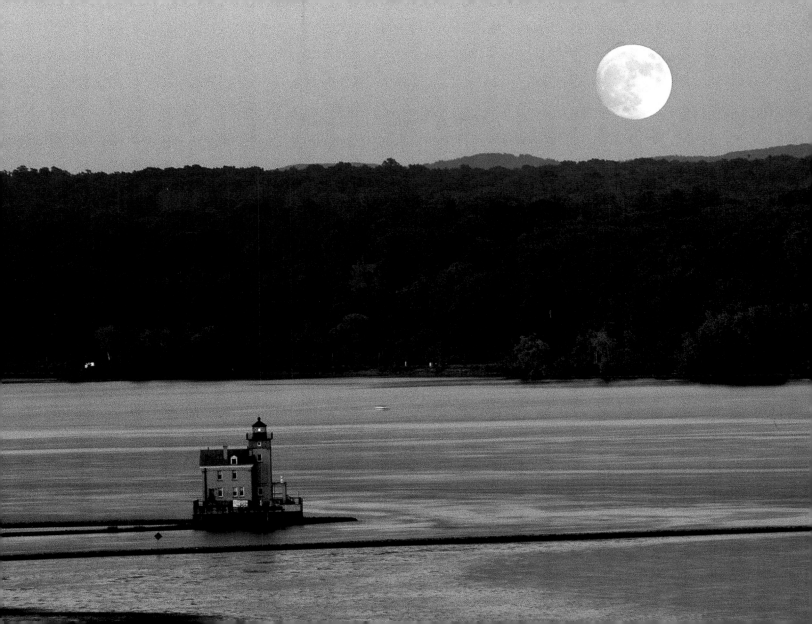

The Hudson of LITERATURE

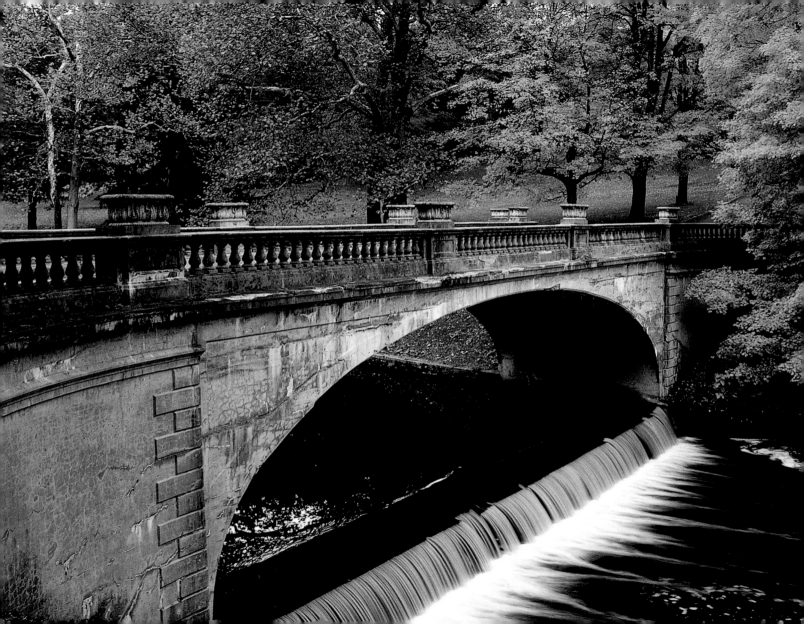

THE AMERICAN METROPOLIS has been pictured as a dreary place, where even the rich live in caves cut into the faces of the canyons named streets and lighted by glazed apertures called windows. But New York's pillars of Hercules, happily, do not stand on the banks of the Harlem. The boundaries of the city are really set far beyond Poughkeepsie, so many of the modern Knickerbockers have country seats on the heights on either side of the Hudson River.

Beautiful country seats stretch in almost unbroken line from Yonkers to Hyde Park, and beyond. The little railroad stations, the names of which appear on the time table, are really so many porters' lodges. Dobbs Ferry, Irvington, Tarrytown, and the rest, are in summer time points of assembly for the carriages, surreys, traps, and dog carts which are driven from the heights every morning and evening.

Many of the estates along the stream are ancestral. The old Knickerbockers loved this land which the captain of the Half Moon saw and pronounced very good. The patroons had country homes along the Hudson centuries ago, and the settlements

Vanderbilt Mansion National Historic Site, Hyde Park.

still ring with the names of Livingston, De Peyster, and Roosevelt . . . Estates which were falling into decay have been purchased by citizens of Manhattan. The landscape gardener, under the supervision of the new owner, has brought out the old lines anew, and has laid out roads and graded the lawns on other levels. With the assistance of city architects, additions have been placed upon country houses, and the electrician, the plumber, and a host of other artisans have made the old dwellings homes of luxury. Acres of farming land have been transferred to city owners, and the original sons of the glebe have been driven steadily back from the banks of the Hudson. The farm house has given place to the modern castle, and the dingy barn to the breeding stable of the gentleman farmer.

He who has a country seat along the Hudson may wield the putter on his own golf links, drive on his own roads, hunt in his own preserves, or go aboard his yacht from his own pier. His table is supplied from the richness of his own land. He is surrounded by a small army of retainers, to whom his every wish is law. Except for the

Vanderbilt Mansion.

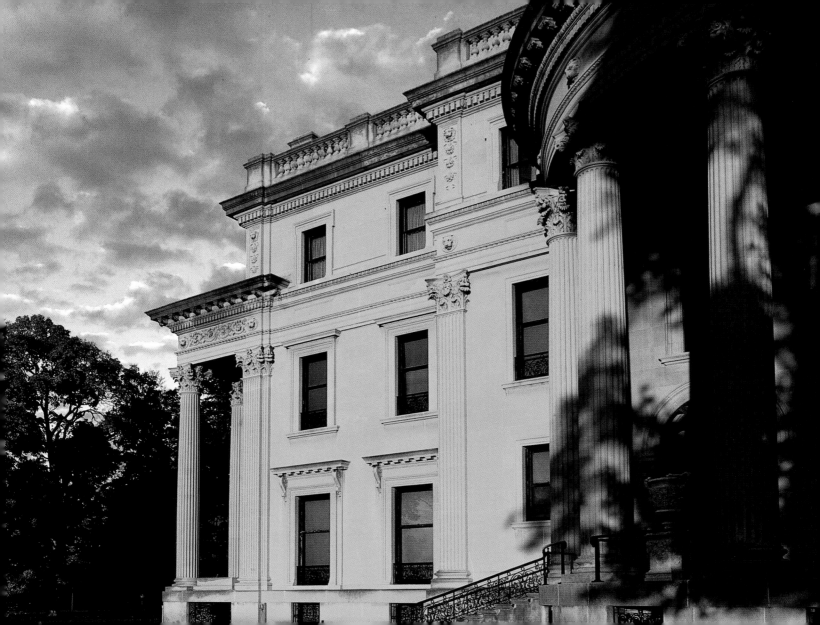

126

Vanderbilt Mansion gardens.

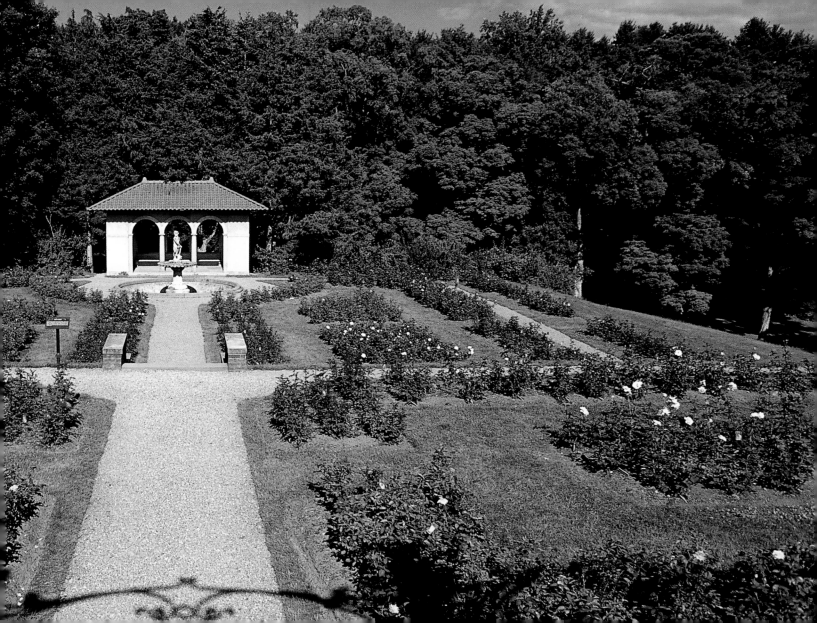

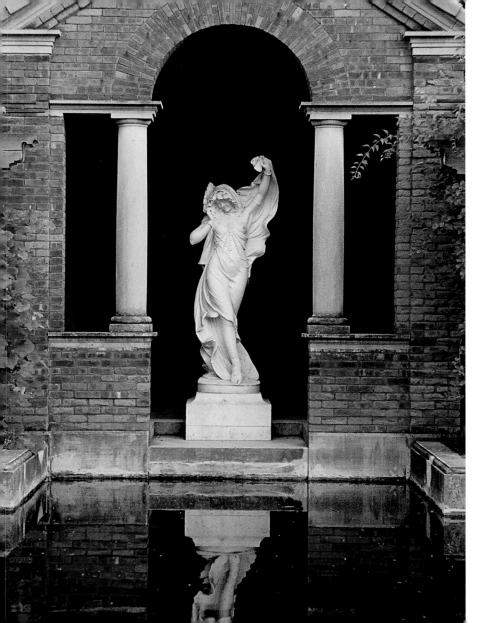

Vanderbilt Mansion gardens.

drawbridge and the dungeon keep, his house is as much of a castle as any pile of stone erected by feudal barons on the crags above the river Rhine . . .

The principal amusements of the Knickerbocker at his Hudson home are golf, yachting, and driving. He takes delight in being in the open air and in drinking in the prospect of the waving forests and the ever changing river. Often he comes up from the city on his own yacht, and reaches a club station on his own pier in the twilight. He finds pleasure in driving the white rubber ball, and in raising a thirst for oatmeal water, and perhaps for Scotch whisky, as he tramps over the links. Whatever he does, this Hudson River country makes him a happier and freer man.

JOHN W. HARRINGTON, *Summer Homes on the Hudson River, 1899*

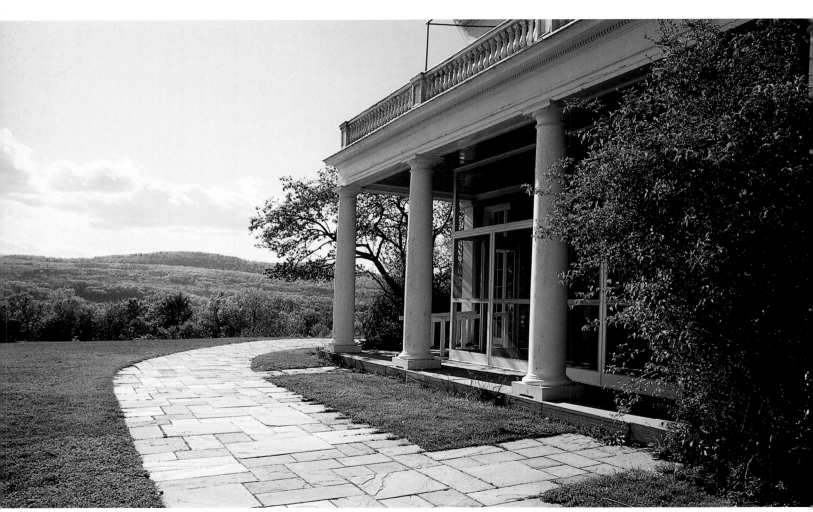

Above and opposite: Franklin D. Roosevelt National Historic Site, Hyde Park.

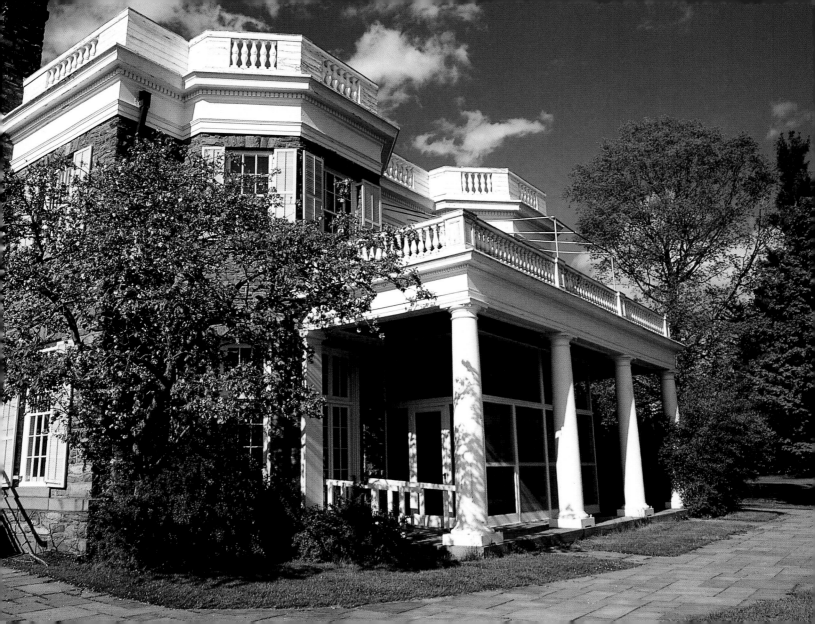

132

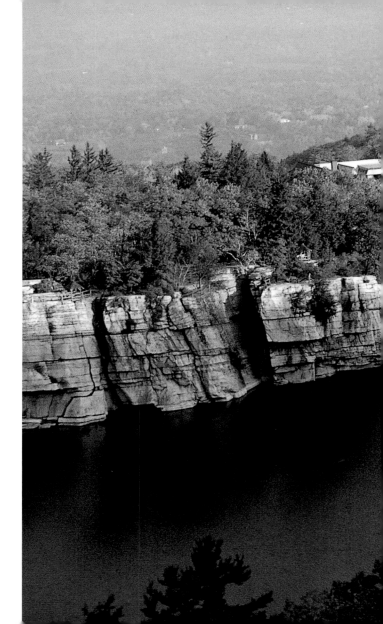

Mohonk Mountain House, near New Paltz.

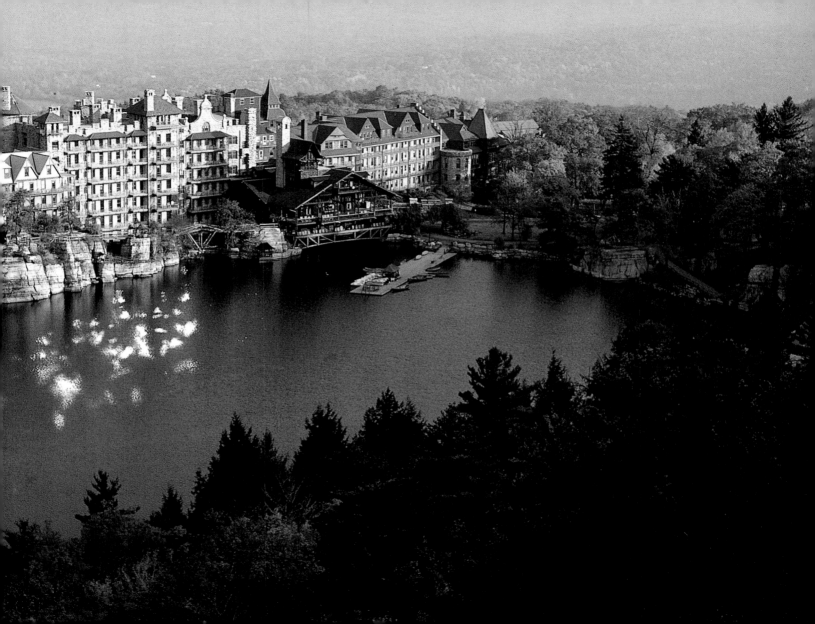

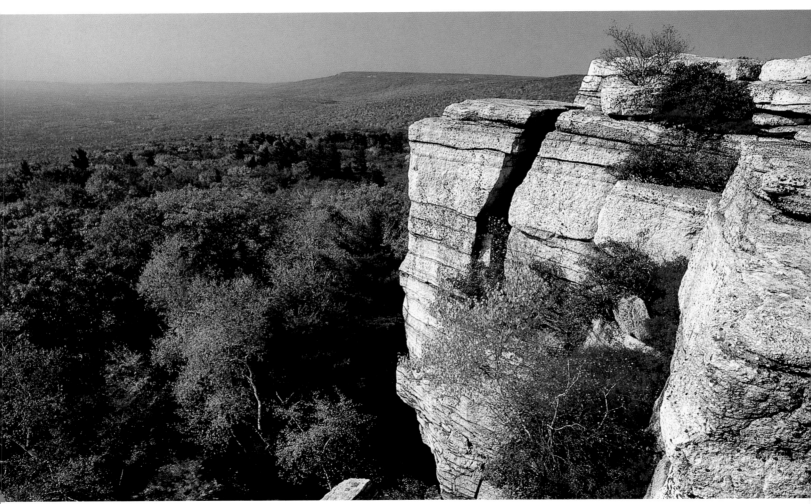

Above: Gertrude's Nose, Shawangunk Mountains, Minnewaska State Park. *Opposite:* Shawangunk Mountains.

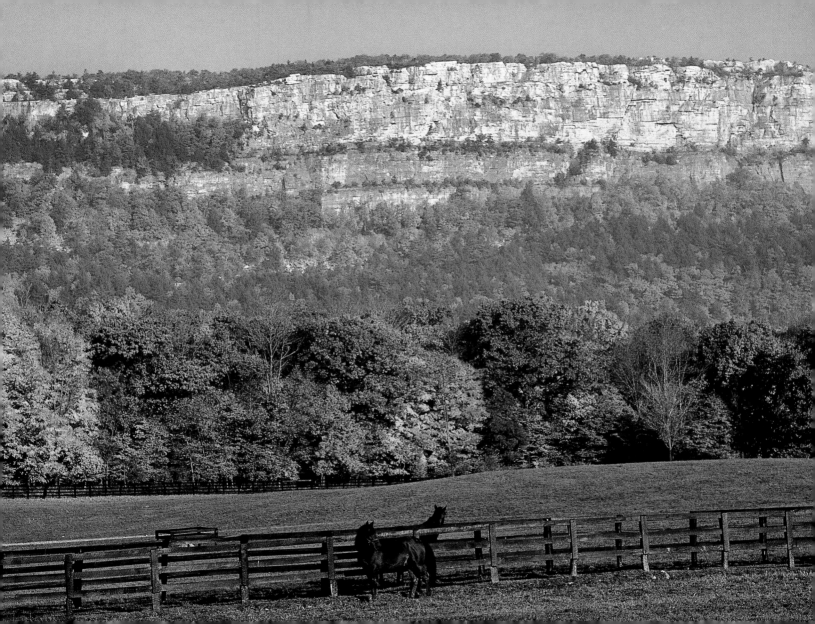

TRADITION ATTRIBUTES the settlement at New Paltz to one of the incidents connected with the Indian massacre at Esopus in June 1663. Catherine Blanshan, the wife of Louis DuBois, was one of the captives carried away into the wilderness. DuBois with a band of the settlers started in pursuit, and, in following the stream which was afterwards called the Wallkill, they noticed the rich lands in the vicinity of the present village of New Paltz. The search was successful, the prisoners were rescued from captivity, and in the more leisurely return to Esopus, Louis DuBois and his companions examined carefully the land which, by its beauty and apparent fertility, had before attracted their attention. Some years afterwards (May 1677), he and his associates purchased from the Indians the large tract of land, estimated to contain some 36,000 acres, including part of the present township of New Paltz, Rosendale, and Esopus, and the whole of Lloyd,—bounded on the west by the Shawangunk Moutains and on the east by the Hudson River. For this valuable grant the Indians

Huguenot House, New Paltz.

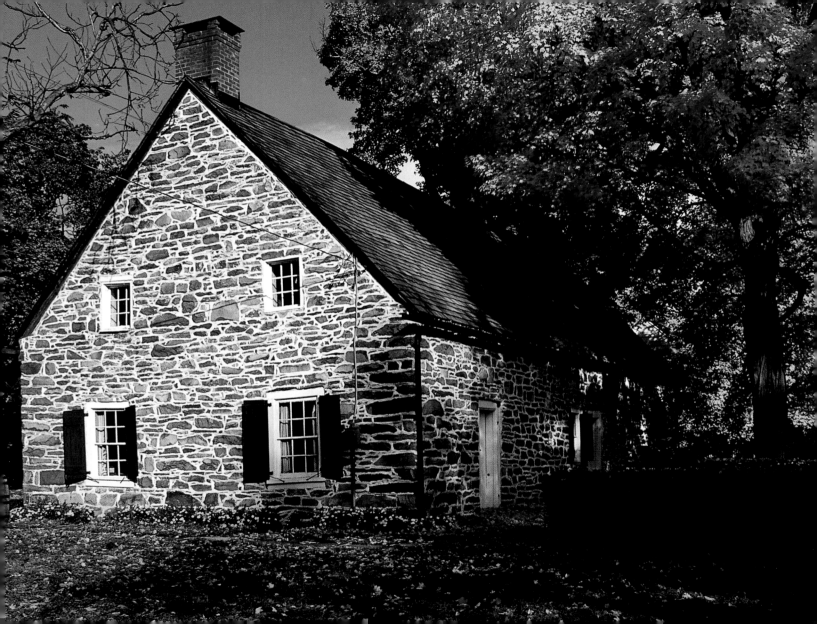

received "40 kettles, 40 axes, 4 adzes, 40 shirts, 400 strings of white beads (wampum), 300 strings of black beads, 50 pairs of stockings, 100 bars of lead, 1 keg of powder, 100 knives, 4 quarter-casks of wine, 40 jars, 60 splitting or cleaving knives, 60 blankets, 100 needles, 100 awls, and 1 clean pipe" . . . All were Huguenots, who fleeing from kingly and church persecution in France, had found an asylum in the Lower Palatinate at Mannheim, and had probably spent some time in Holland also, whence they had come with the Dutch to Esopus. In memory of their German home on the banks of the Rhine and adjacent to the forest region of the Odenwald, they named their new home on the Hudson, New Paltz, or the New Palatinate, and here established, to a considerable degree, the local government and peculiar customs of the German village community.

IRVING ELTING, *Dutch Village Communities on the Hudson River, 1886*

Opposite and overleaf: Minnewaska State Park.

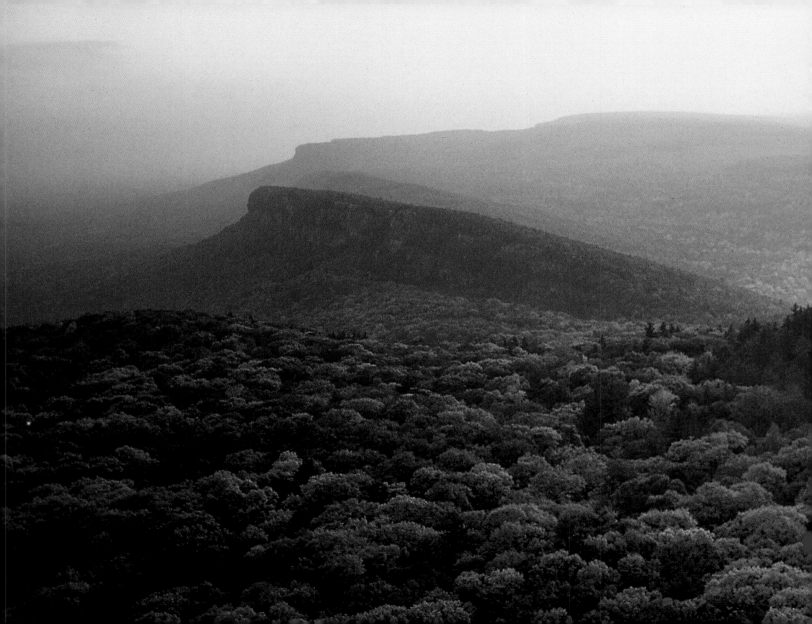

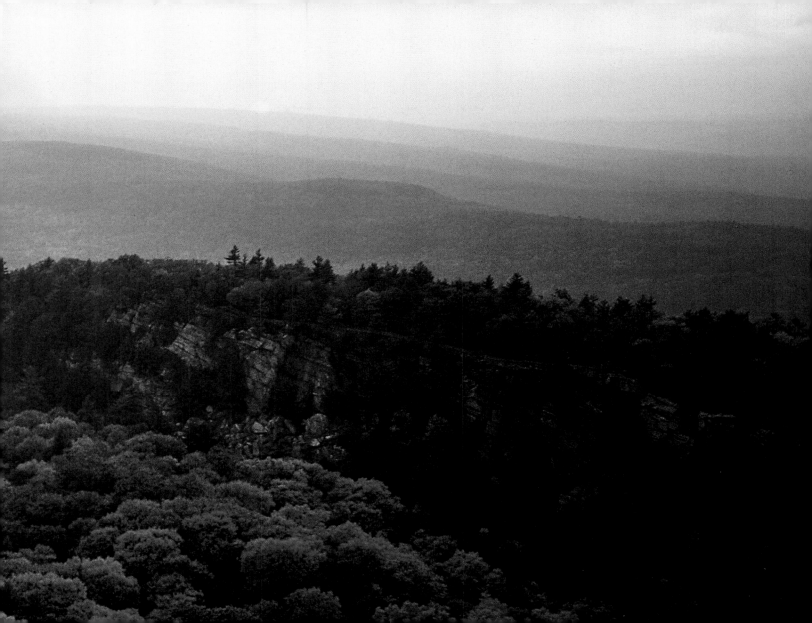

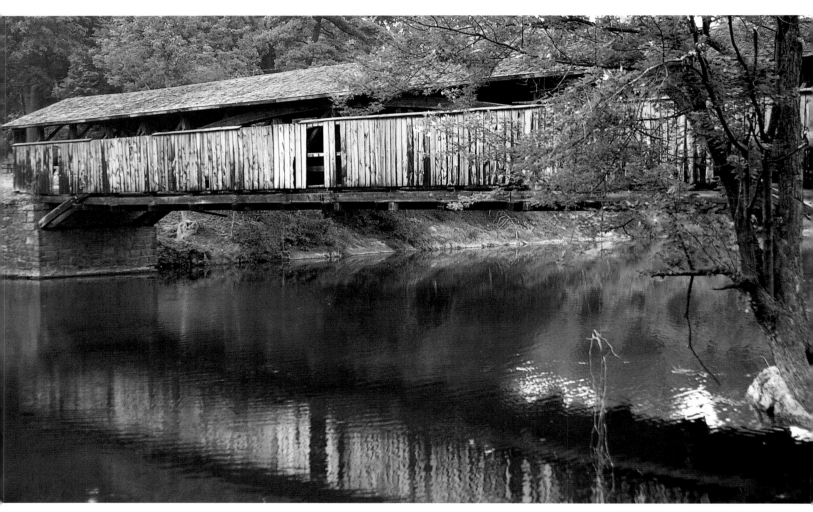

Rifton Covered Bridge over the Walkill River.

Wildflowers.

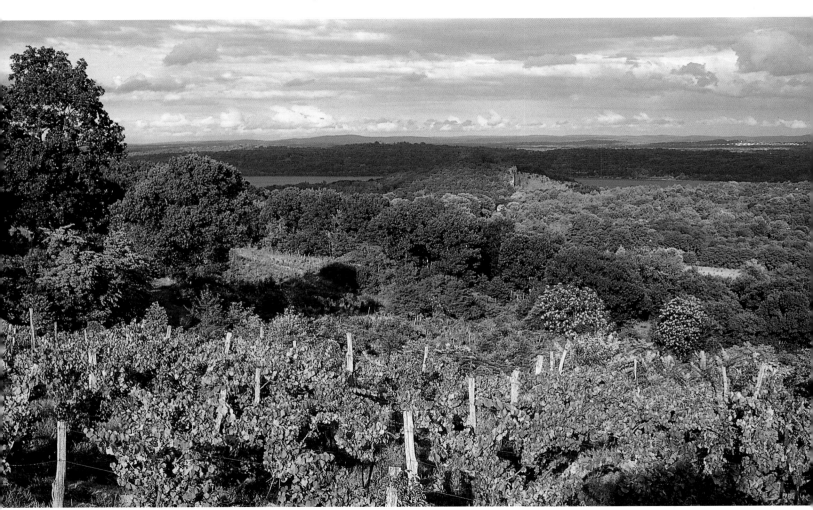

Above: Vineyards in Marlboro. *Opposite:* Newburgh.

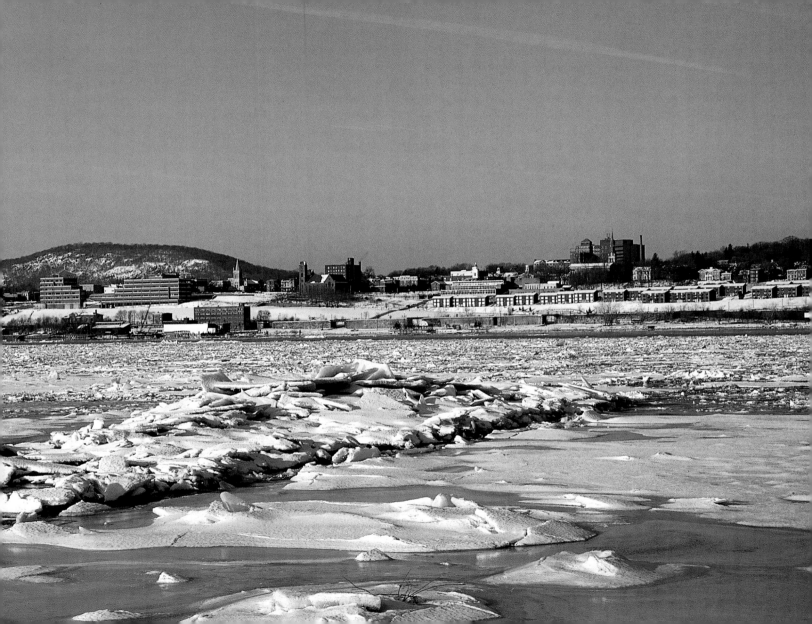

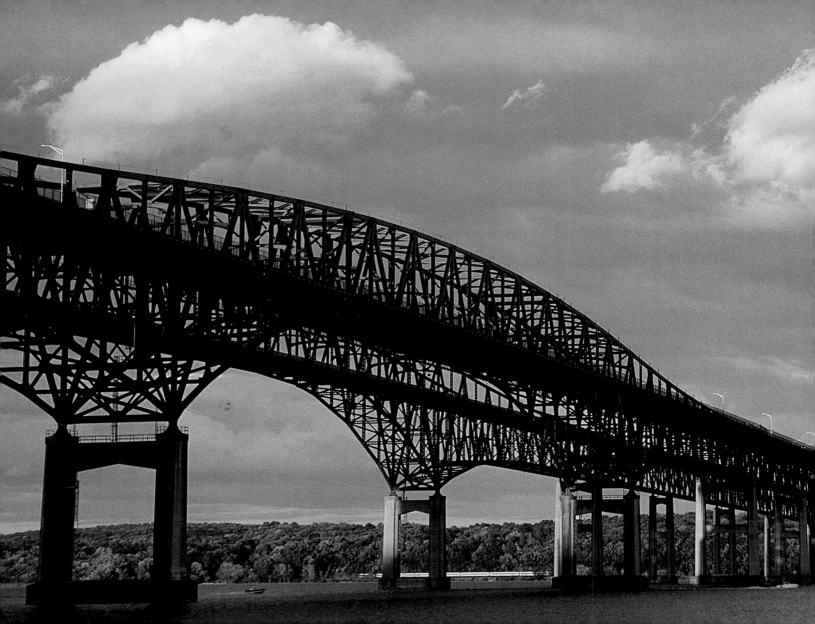

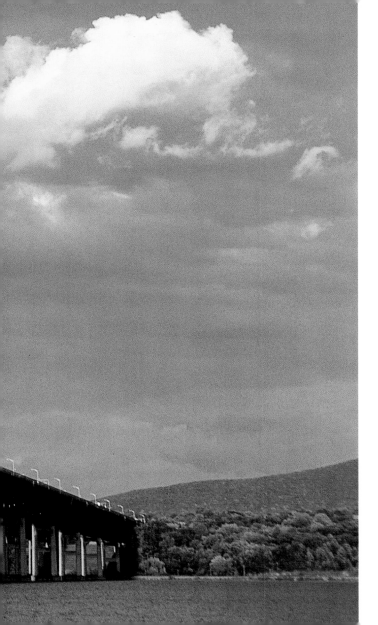

147

Newburgh Bridge.

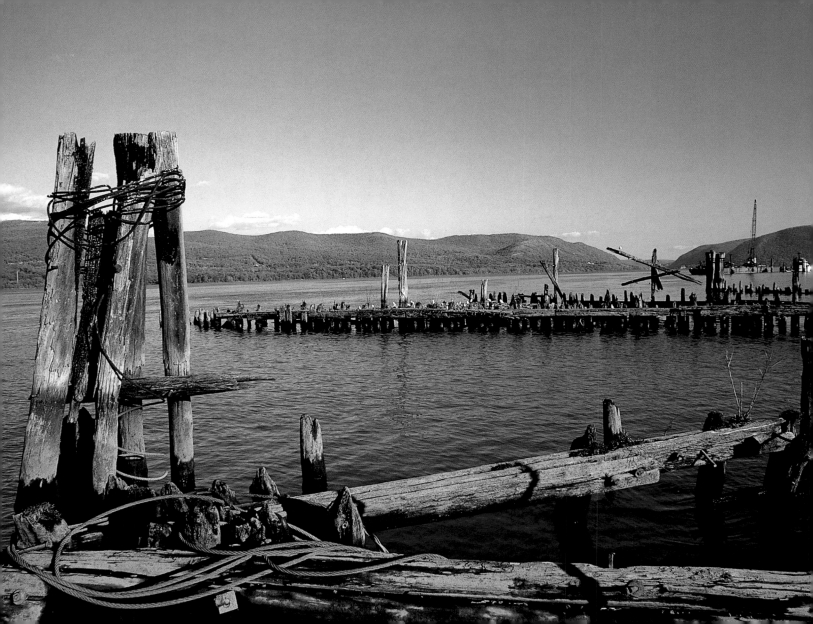

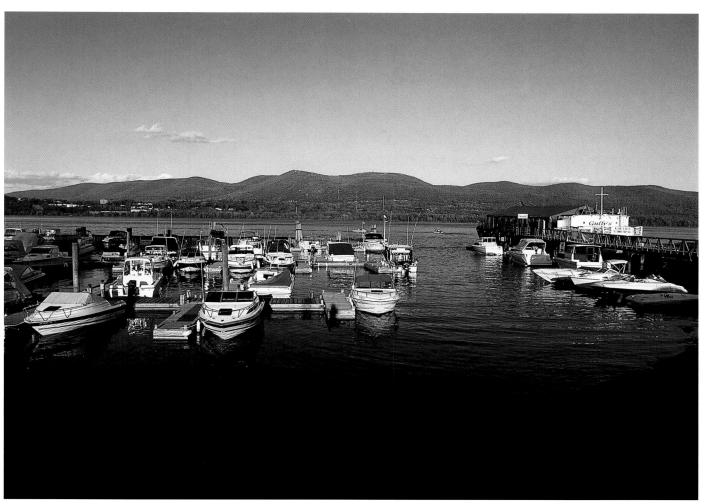

Above and opposite: Newburgh.

THE MAN WHOSE IMAGINATION and energy are solely responsible for the building of the castle, the towers, the portcullis and everything on the Island was Frank Bannerman VI. He was born in Dundee, Scotland, in 1851 and came to this country when he was three years old. The family settled in Brooklyn where his father established a business of selling articles acquired at Navy auctions, particularly flags, ship chandlery, and rope . . . In addition to an active interest in local and world affairs

Francis Bannerman was a student of antiquities of all kinds but especially of military matters. Probably the greatest interest was collecting, on his travels to all parts of the world, unusual items for the museum which he maintained in his store in New York. Some of the armor was at one time exhibited in the Metropolitan Museum of Art. The building of the castle on the Island was a new field of study—the architecture of castles all over Europe, especially Scotland, including minute details of decorations. Many of his plans and ideas were never completed, although building continued uninterrupted from 1900 until he died in November 1918.

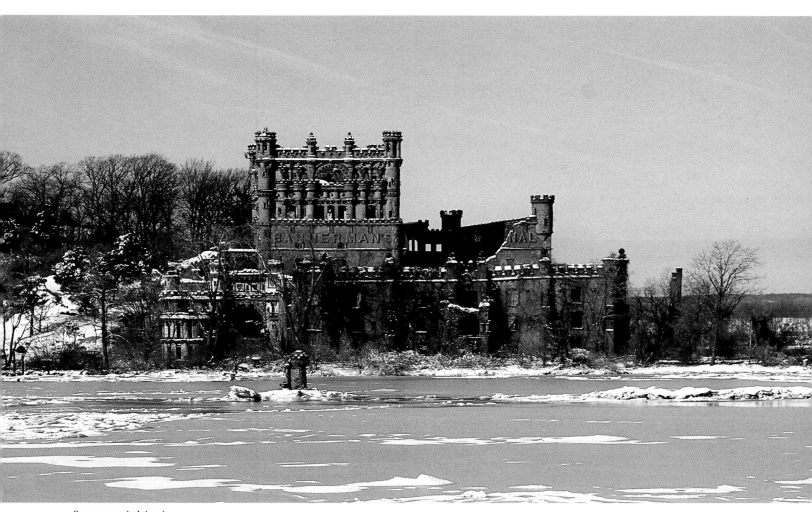

Bannerman's Island.

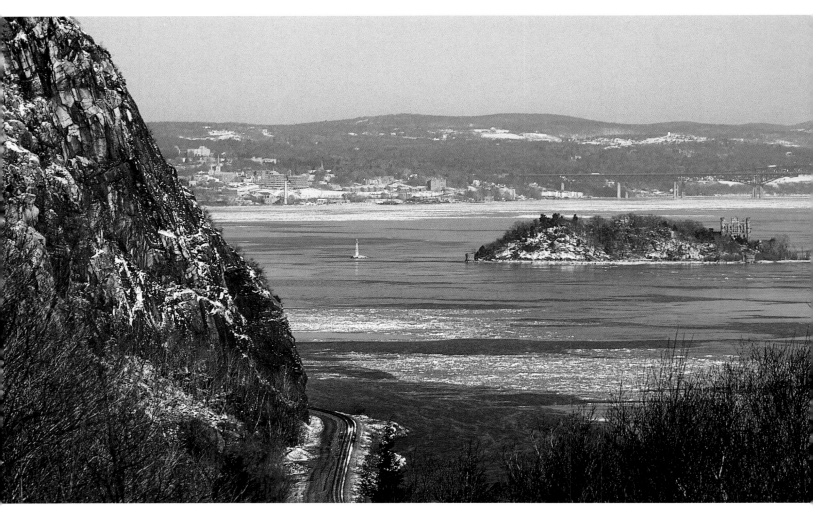

Bannerman's Island.

The house resembles a Scottish castle with its turrets and crenellated towers . . . Francis Bannerman continued until his death to his own designs, under his personal supervision, the No. 3 arsenal, the Tower, his personal residence, the work shop and the residence apartments for the workmen, docks, turrets, walls, breakwaters, powder house, ice house, garden walks, and all their elaborate decorations. Almost all of it was done without professional assistance from architects, engineers and contractors.

CHARLES S. BANNERMAN, *The Story of Bannerman Island, 1962*

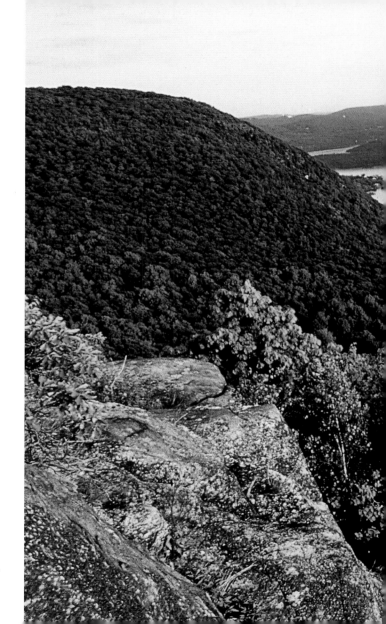

154

View of the river from Storm King Mountain.

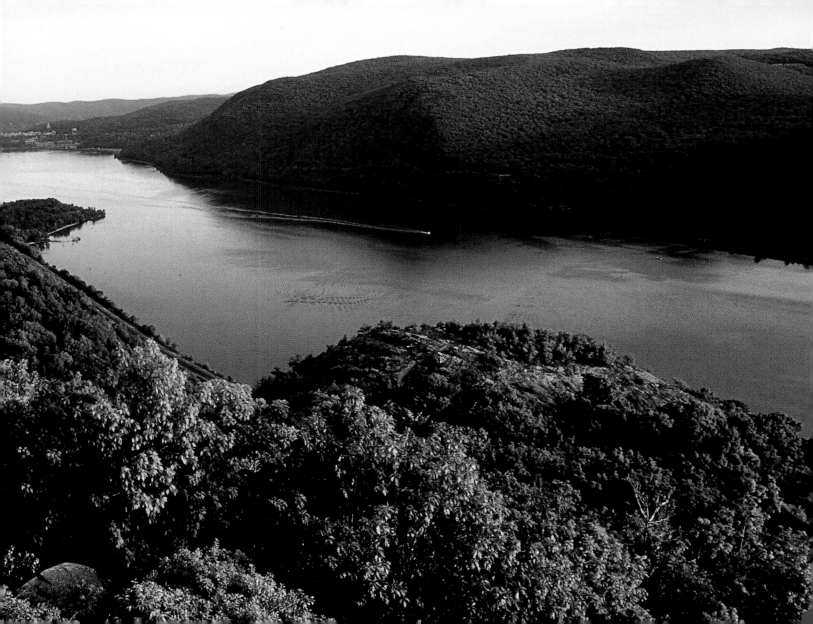

STORM KING. Twenty-five years ago, an art institution with initially modest ambitions was born into this evocative name. In the years since, the Storm King Art Center has come to embody all the drama and majesty of its mountain namesake. It has evolved into one of the few places in the world where one can begin to measure the exalted aspirations and achievements of postwar sculpture.

JOHN BEARDSLEY, *A Landscape for Modern Sculpture, 1985*

156

Right: Menashe Kadishman, *Suspended,* Storm King Sculpture Park.
Overleaf: Constitution Marsh, Garrison.

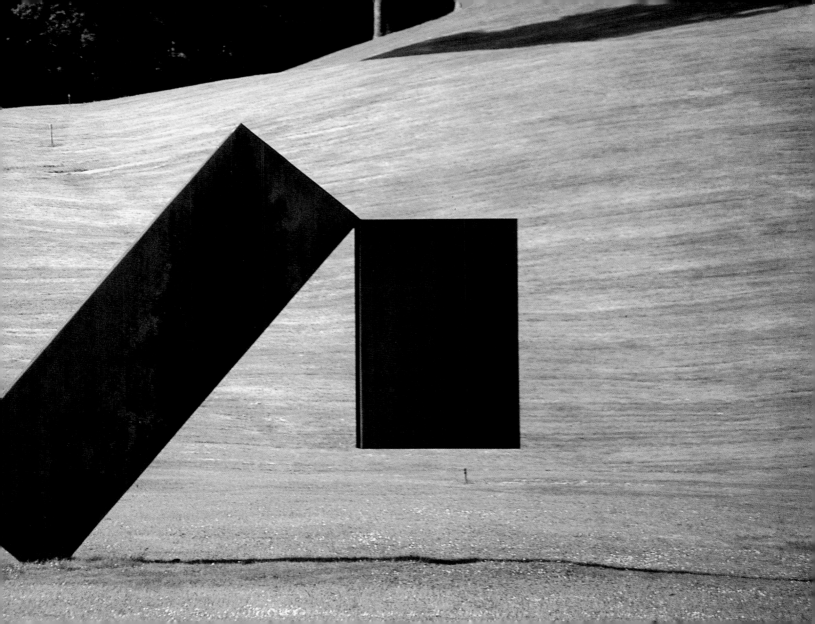

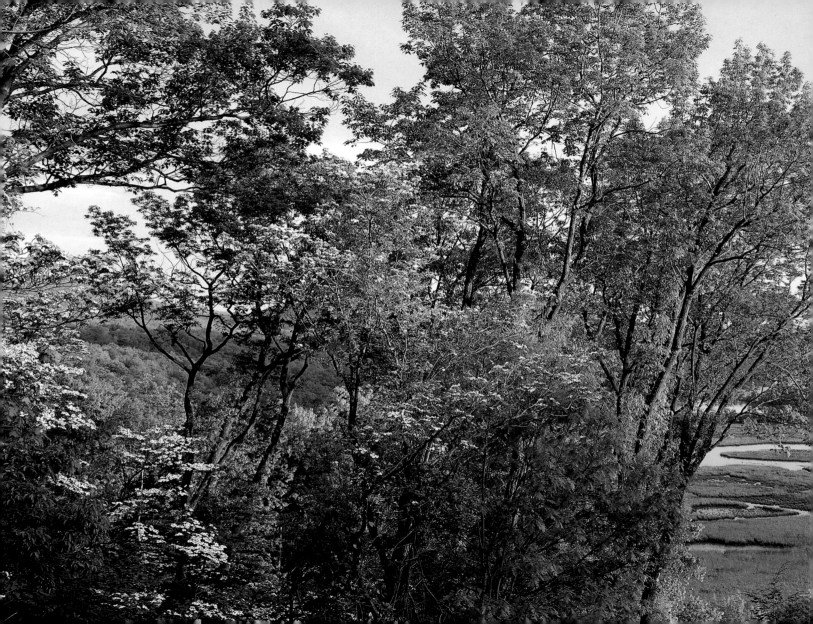

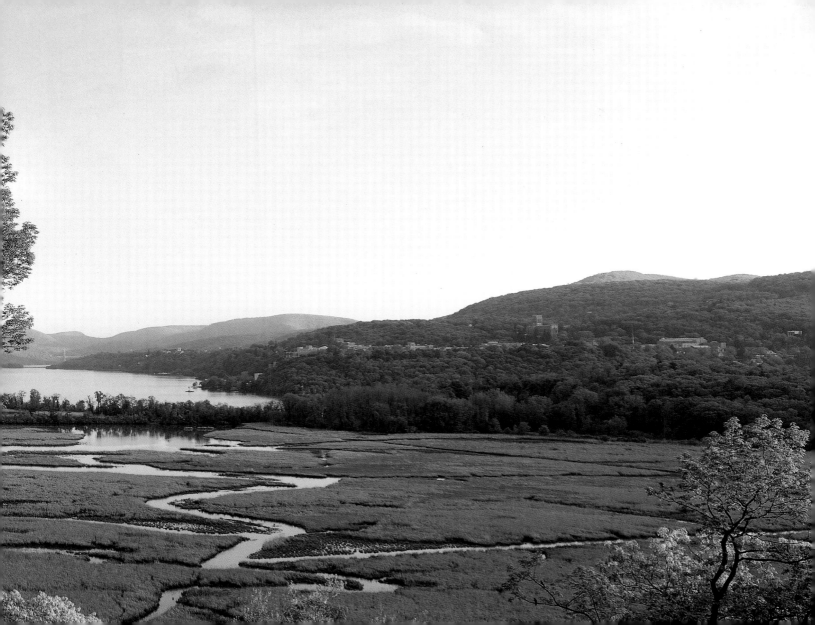

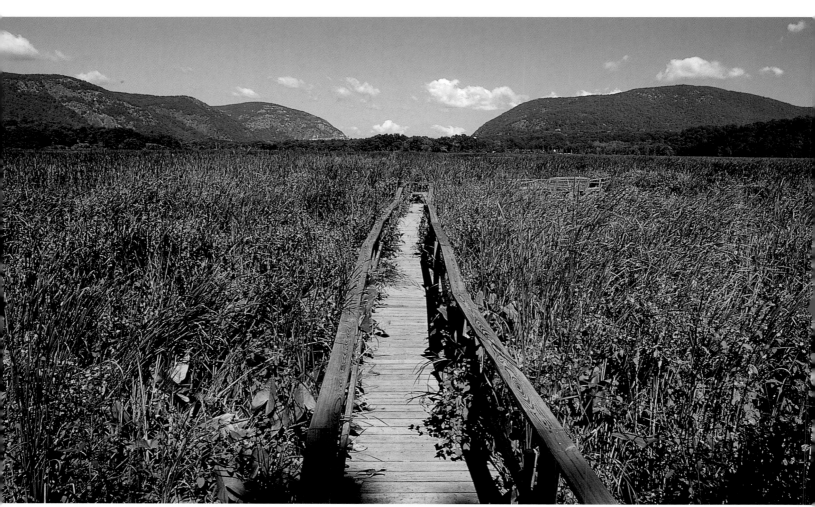

Above: Constitution Marsh. *Opposite:* Boscobel, Garrison.

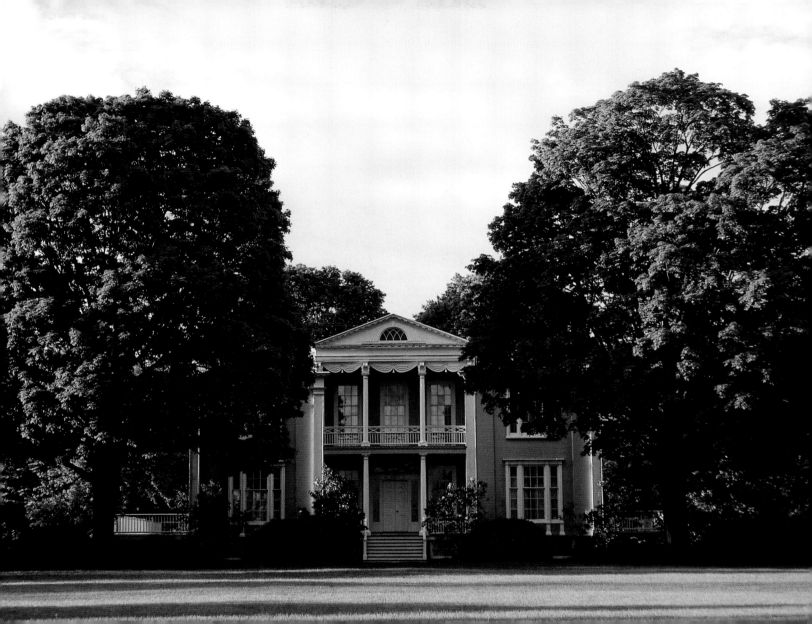

IN THIS BEAUTIFUL PLACE: the fairest among the fair and lovely Highlands of the North River: shut in by deep green heights and ruined forts, and looking down upon the distant town of Newburgh, along a glittering path of sunlit water, with here and there a skiff, whose white sail often bends on some new tack as sudden flaws of wind come down upon her from the gullies in the hills: hemmed in, besides, all round with memories of Washington, and events of the revolutionary war: is the Military School of America. It could not stand on more appropriate ground, and any ground more beautiful can hardly be.

CHARLES DICKENS, *American Notes, for General Circulation, 1871*

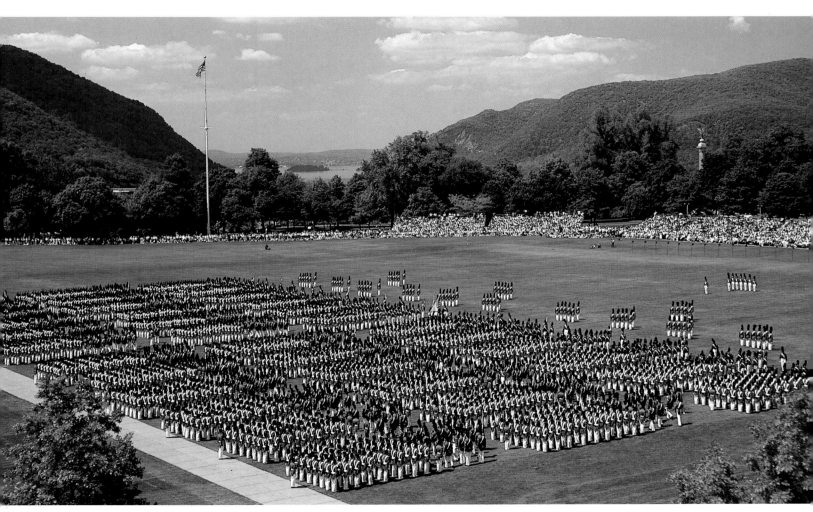

Graduation Parade, U.S. Military Academy, West Point.

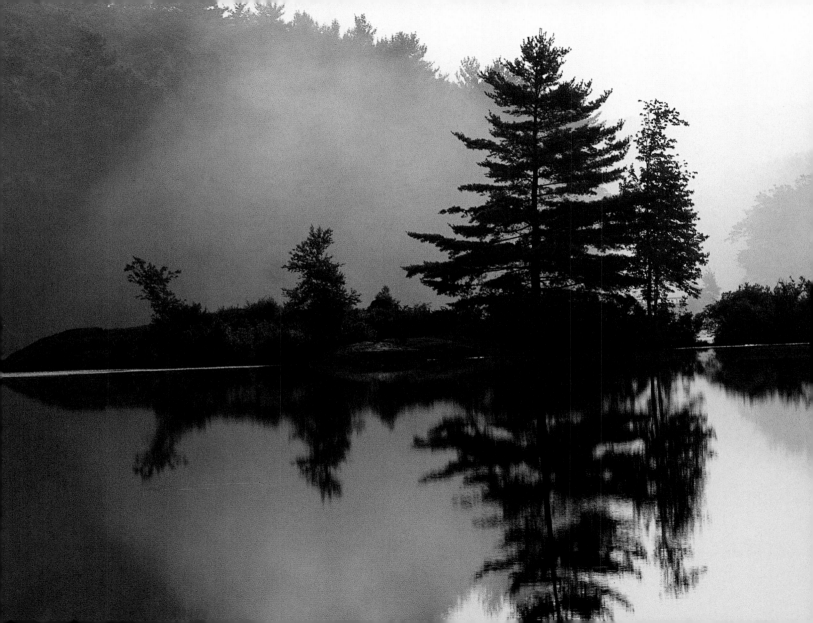

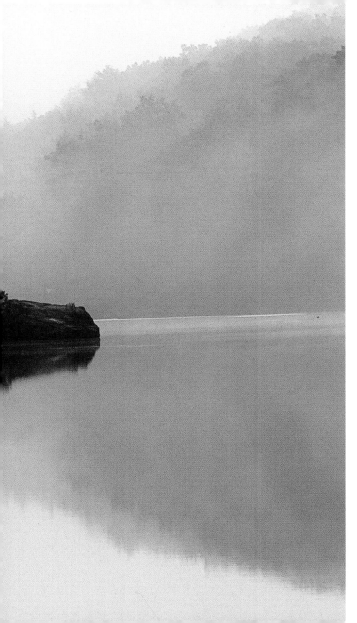

165

Left: Little Long Pond, Harriman State Park.
Overleaf: Hudson Highlands, Harriman State Park.

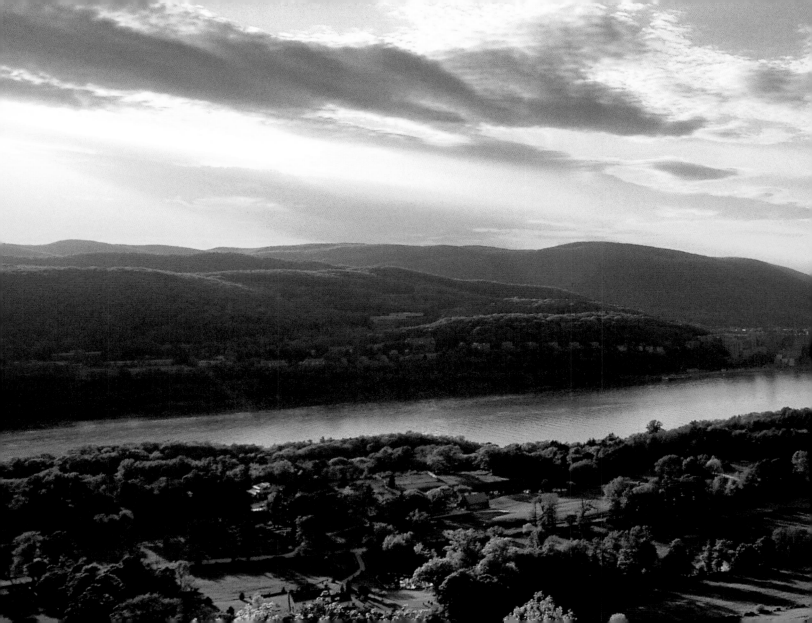

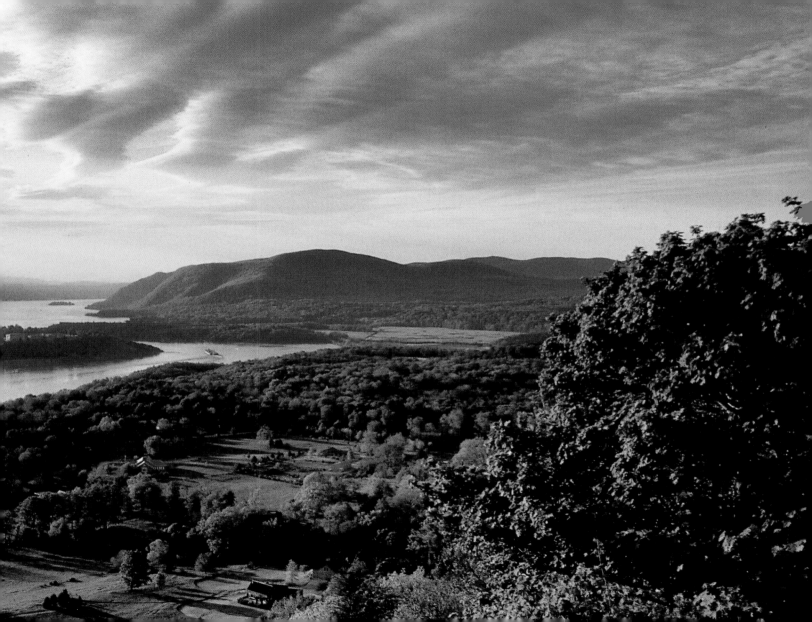

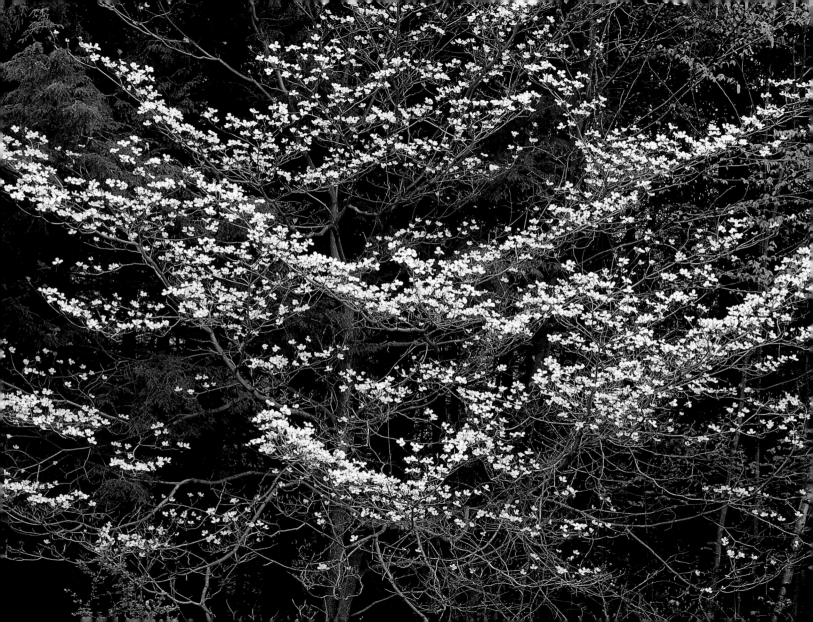

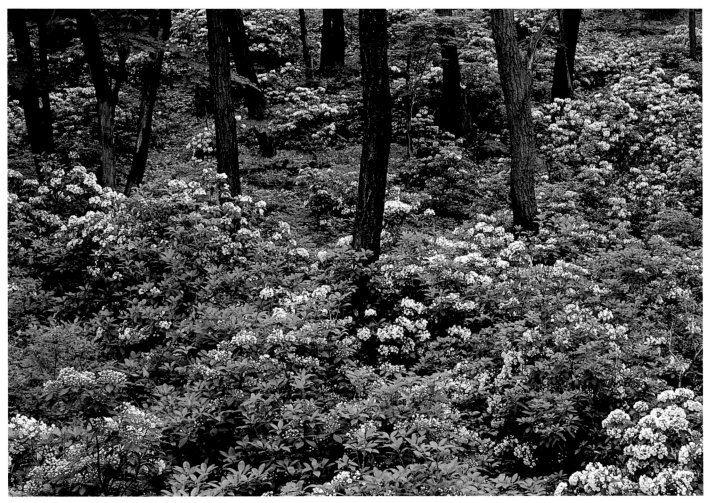

169

Above, opposite, and overleaf: Harriman State Park.

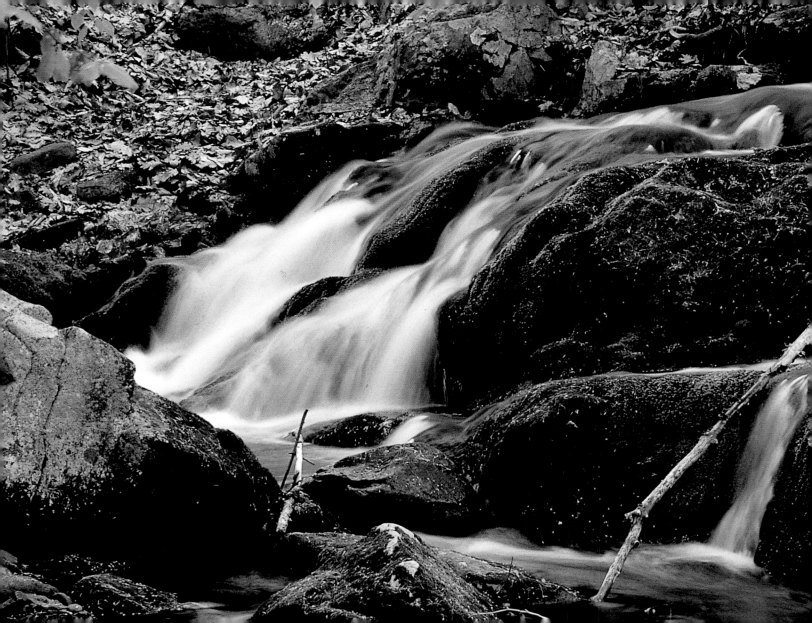

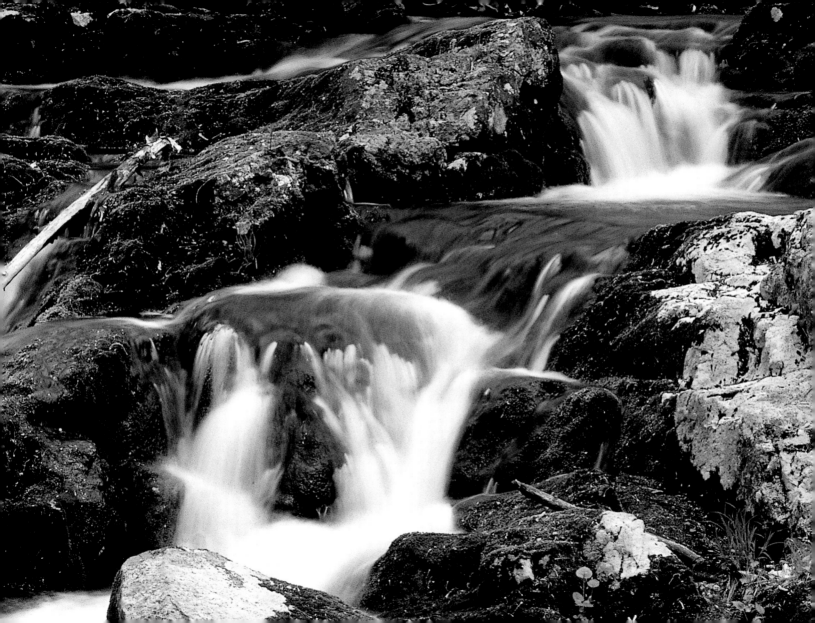

CORTLANDT MANOR HOUSE STANDS near the shore of Croton Bay. It was erected at the beginning of the last century, by John Van Cortlandt, eldest son of the first lord of the manor, and is now more than one hundred and fifty years old. Orloff Stevenson Van Cortlandt, father of the first proprietor of this estate, was a lineal descendant of the Dukes of Courland, in Russia. His ancestors emigrated to Holland, when deprived the Dutchy of Courland. The family name was Stevens, or Stevensen, Van (or from) Courland. They adopted the latter as a surname, the true orthography of which, in Dutch, is Korte (short), and landt (land), a term expressing the form of the ancient Duchy of Couland. Orloff emigrated to America, and settled in New Amsterdam (New York), and in 1697 his son Stephen purchased the large estate on the Hudson, afterwards known as the Van Cortlandt Manor. By intermarriages, the Van Cortlandts are connected with nearly all the leading families of New York—the Schuylers, Beekmans, Van Rensselaers, De Peysters, De Lanceys, Bayards, &c. The Manor

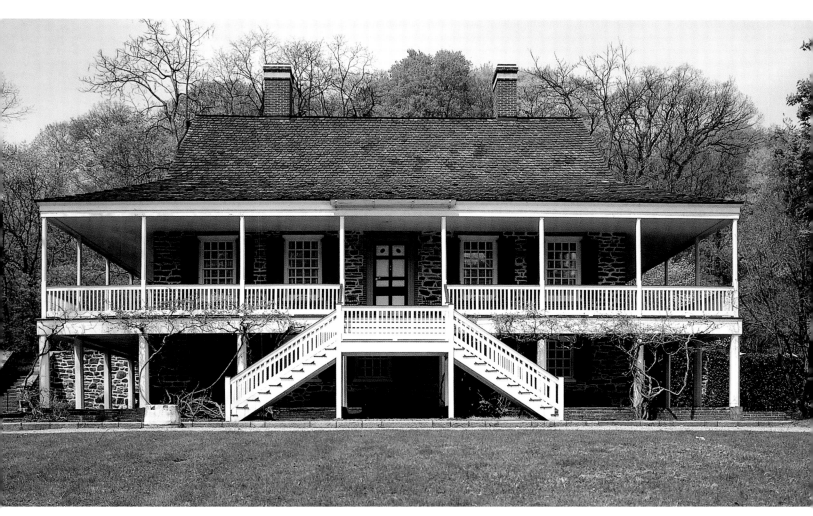

Van Cortlandt Manor, Croton-on-Hudson.

House was built of heavy stone; and the thick walls were pierced with loopholes for musketry to be used in defense against the Indians. It has been somewhat changed in aspect, by covering the round stone with stucco. Its front, graced by a pleasant lawn, commands an extensive view of the bay, and of the Hudson beyond. In that bay, under the shelter of Croton Point, Hendrick Hudson anchored the Half-Moon, on the evening of the first of October, 1609; and such a resort were these waters for canvas-back ducks, and other water-fowl, that, as early as 1683, Governor Dongan came there to enjoy the sport of fowling. There, too, great quantities of shad were caught. But its glory is departed. The flood of 1841, that swept away the Croton Dam, almost filled the bay with earth; it is accumulating there every hour; and, in the course of a few years, the Van Cortlandt estate will have many acres of fine meadow land added to it, where once large vessels might ride at anchor.

BENSON JOHN LOSSING, *The Hudson: From the Wilderness to the Sea, 1866*

Ossining.

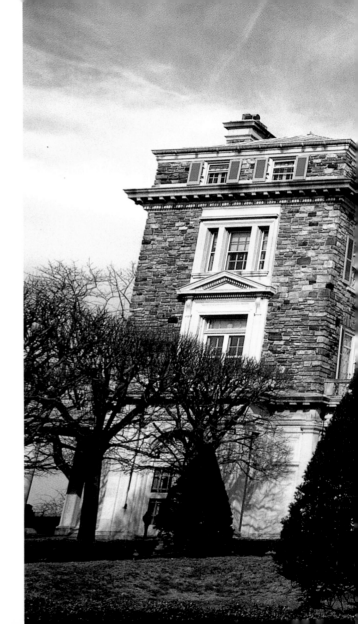

Kykuit, Pocantico Hills.

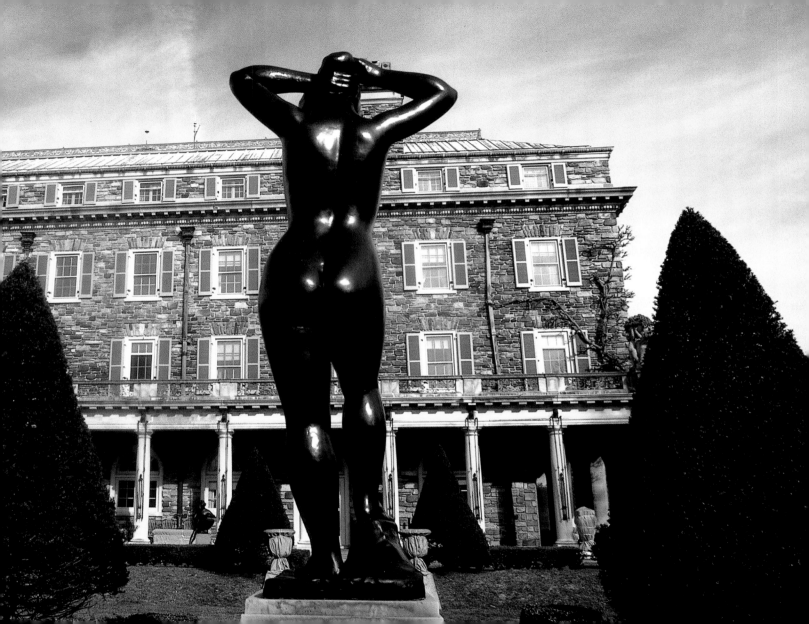

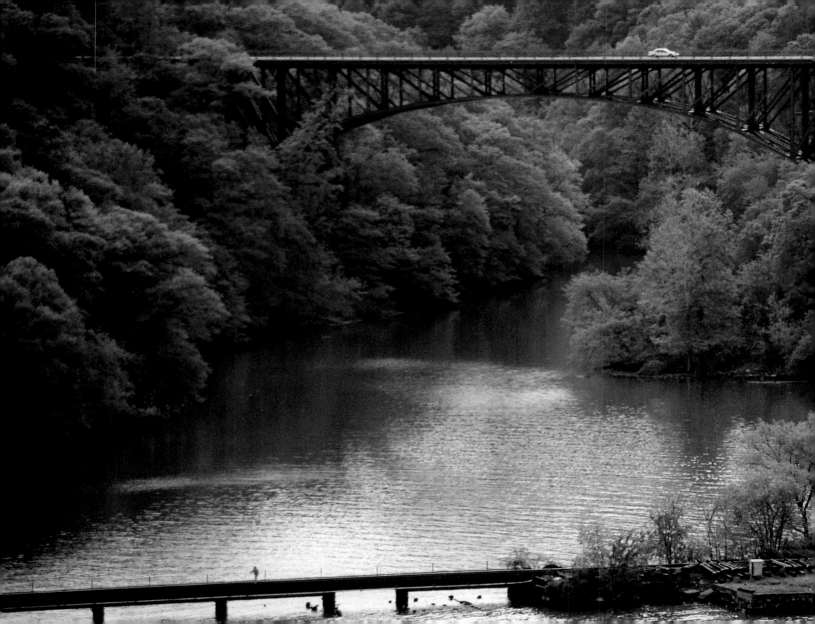

Popolopen Bridge.

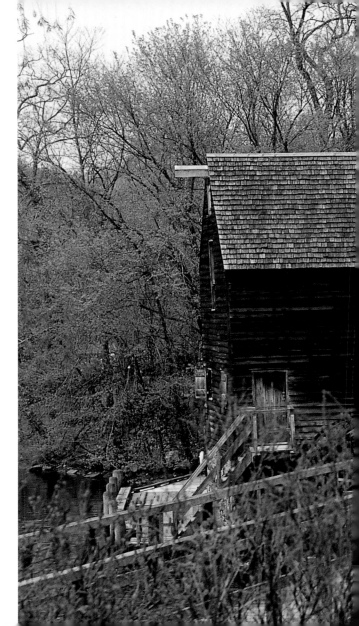

180

Philipsburg Manor, North Tarrytown.

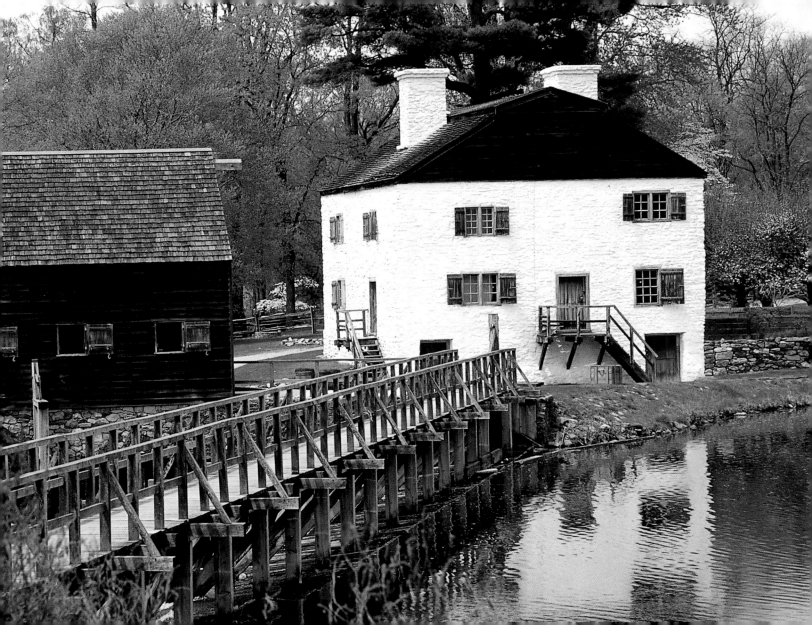

LYNDHURST, as it came to us, portrayed within the shell of one architectural monument three important eras in American life.

The first period is revealed in the original core of the house, as designed in 1838 for General William Paulding by Alexander Jackson Davis, the well-known nineteenth-century American architect. The second period, that of the tower and the dining-room wing addition, was designed for George Merritt in 1864, also by Davis.

The third period began when Jay Gould in 1880 became its purchaser. Mr. Gould died in 1892 and his oldest daughter Helen, Mrs. Finley Shepard, continued to live at Lyndhurst until her death in 1938. Finally, in 1939 Gould's second daughter, Anna, the Duchess of Talleyrand-Perigord, returned from France to live in New York City and Tarrytown. After her death the estate came to the National Trust in 1964; the restoration began the following year.

LYNDHURST: *A Property of the National Trust for Historic Preservation, 1965*

Lyndhurst, Tarrytown.

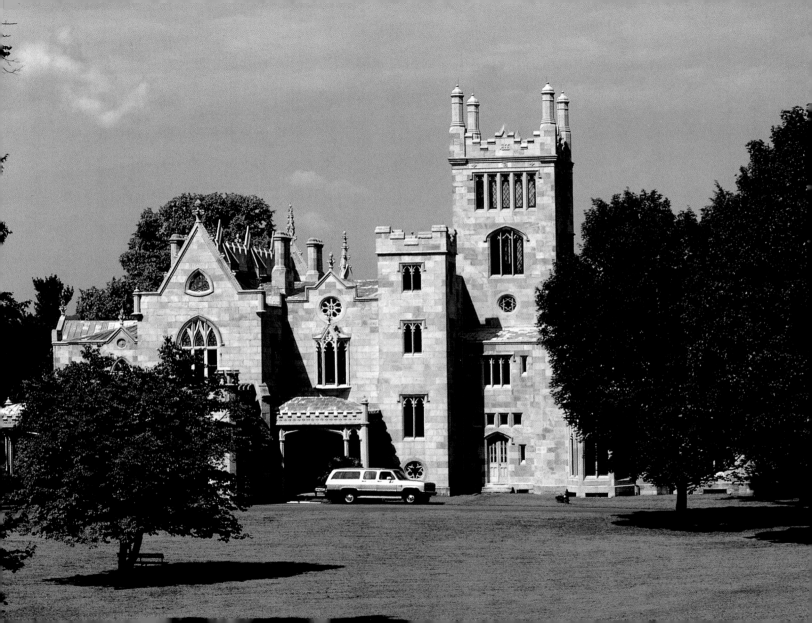

Above and opposite: Sunnyside, Tarrytown.

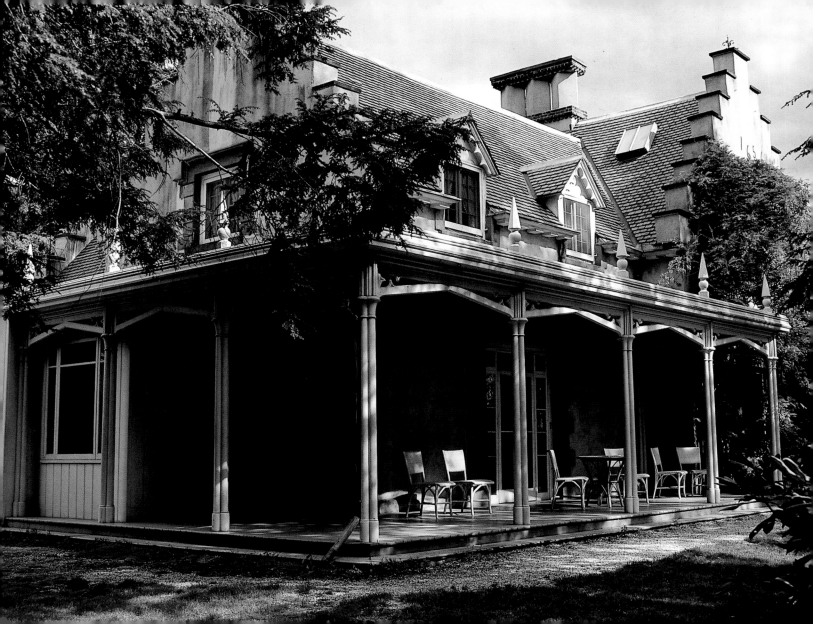

The Hudson of COMMERCE

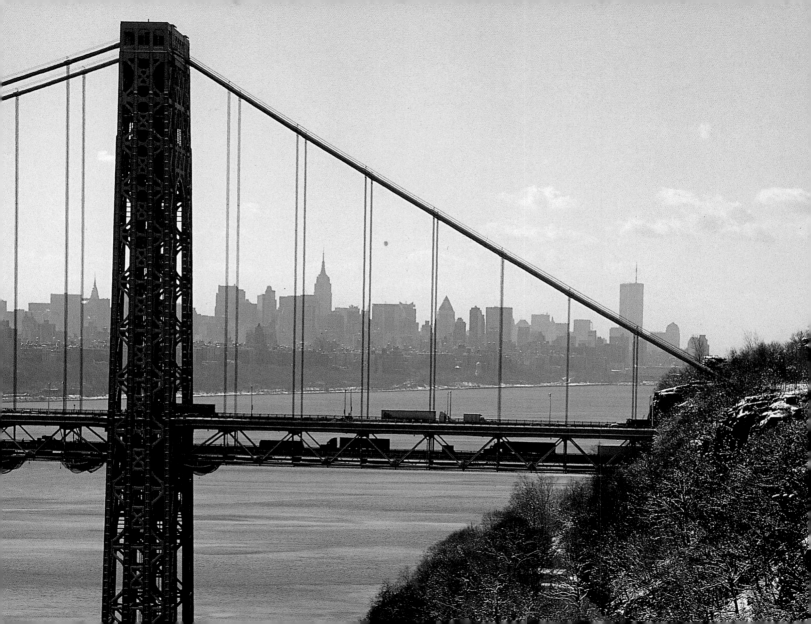

SHE IS THE ONLY CITY whose lovers live always in a mood of wonder and expectancy. There are others where one may sink peacefully, contentedly into the life of the town, affectionate and understanding of its ways. But she, the woman city, who is bold enough to say he understands her? The secret of her thrilling and inscrutable appeal has never been told. How could it be? She has always been so much greater than any one who has lived with her. (Shall we mention Walt Whitman as the only possible exception? O. Henry came very near to her, but did he not melodramatize her a little, sometimes cheapen her by his epigrammatic appraisal, fit her too neatly into his plot? Kipling seemed to see her only as the brutal, heedless wanton.) Truly the magic of her spell can never be exacted. She changes too rapidly, day by day. Realism, as they call it, can never catch the boundaries of her pearly beauty. She needs a mystic . . .

Her air, when it is typical, is light, dry, cool. It is pale, it is faintly tinctured with pearl and opal. Heaven is unbelievably remote; the city itself daring so high, heaven lifts in a cautious remove. Light and shadow are fantastically banded, striped, and patchworked among her cavern streets; a cool, deep gloom is cut across with fierce jags and blinks of

George Washington Bridge.

brightness. She smiles upon man who takes his ease in her colossal companionship. Her clean soaring perpendiculars call the eye upward. One wanders as a botanist in a tropical forest. That great smooth groinery of the Pennsylvania Station train shed: is it not the arching fronds of iron palm trees? Oh, to be a botanist of this vivid jungle, spread all about one, anatomist of the ribs and veins that run from the great backbone of Broadway!

To lover her, one thinks, is to love one's fellows; each of them having some unknown share in her loveliness. Any one of her streets would be the study and delight of a lifetime. To speak at random, we think of that little world of brightness and sound bourgeois cheer that spreads around the homely Verdi statue at Seventy-third Street . . . Within a radius, thereabouts, of a quarter-mile each way, we could live a year and learn new matters every day. They call us a hustling folk. Observe the tranquil afternoon light in those brownstone byways. Pass along leisurely Amsterdam Avenue, the region of small and genial shops, Amsterdam Avenue of the many laundries. See the children trooping upstairs to their own room at the St. Agnes branch of the Public Library. See the taxi drivers, sitting in their cars alongside the Verdi grass plot (a rural breath of new-mown turf sweetening the warm, crisp

Tappan Zee Bridge, between Nyack and Tarrytown.

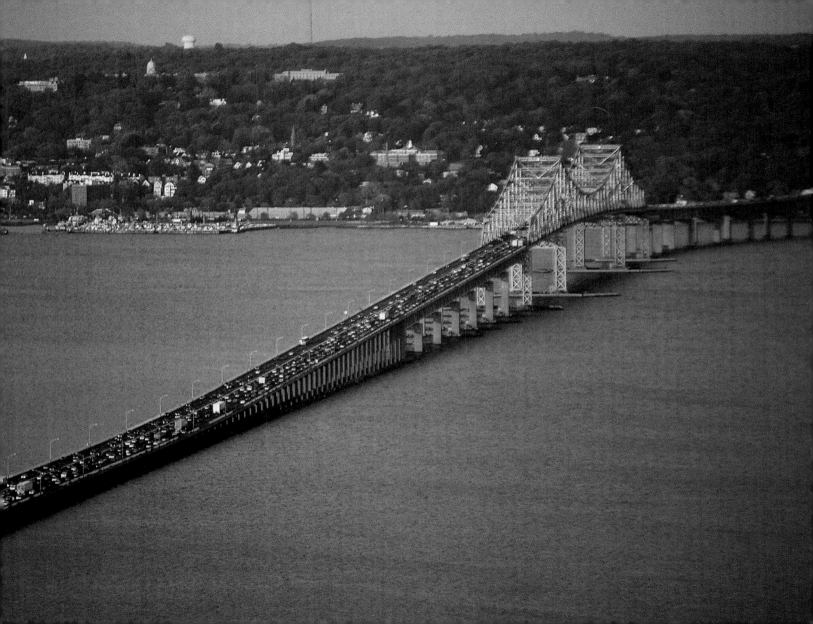

air) and smoking pipes. Every one of them is to us as fascinating as a detective story. What a hand they have had in ten thousand romances. At this very moment, what quaint and many-stranded destinies may hail them and drive off? But there they sit, placid enough, with a pipe and the afternoon paper. The light, fluttering dresses of enigmatic fair ones pass gaily on the pavement. Traffic flows, divides, and flows on, a sparkling river . . .

So she teases us, so she allures. Sometimes on the el, as one passes along that winding channel where the walls and windows come so close, there is a felicitous sense of being immersed, surrounded, drowned in a great, generous ocean of humanity. It is a fine feeling. All life presses around one, the throb and the problem are close, are close. Who could be weary, who could be at odds with life, in such an embrace of destiny? The great tall sides of buildings fly open, the human hive is there, beautiful and arduous beyond belief. Here is our worship and here our lasting joy, here is our immortality of encouragement. Yes, perhaps O. Henry did say the secret after all: "He saw no longer a rabble, but his brothers seeking the ideal."

CHRISTOPHER MORLEY, *"The Anatomy of Manhattan," Pipefuls, 1921*

Indian Head.

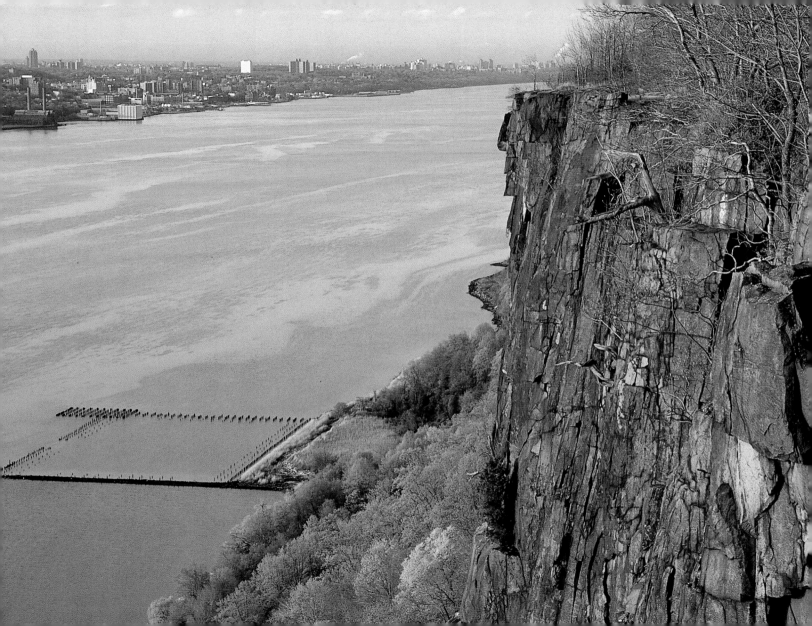

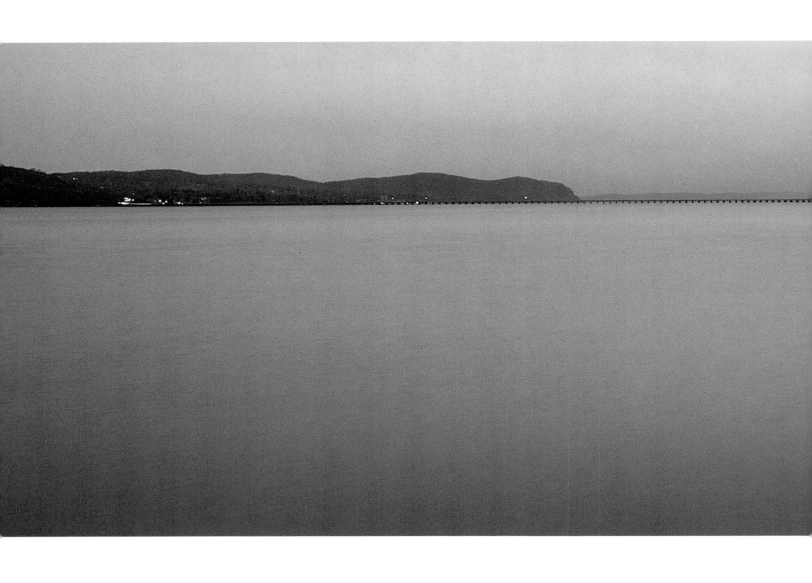

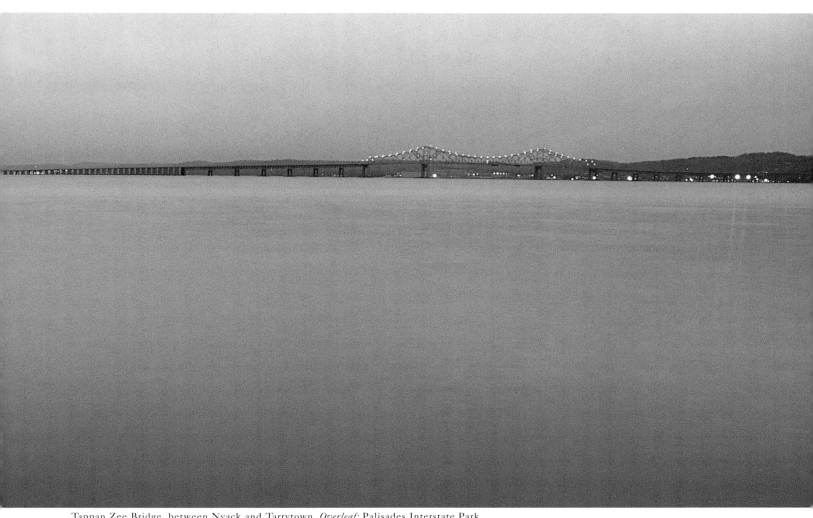

Tappan Zee Bridge, between Nyack and Tarrytown. *Overleaf:* Palisades Interstate Park.

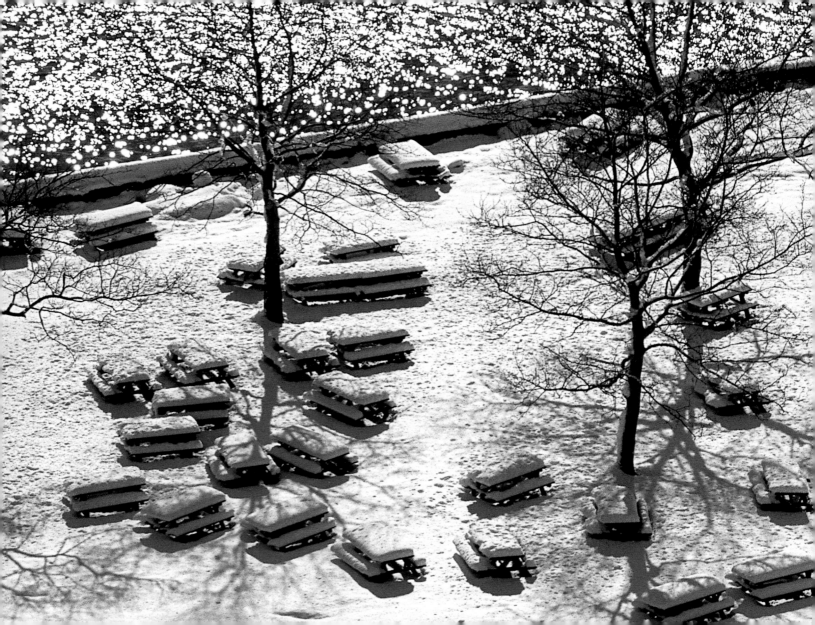

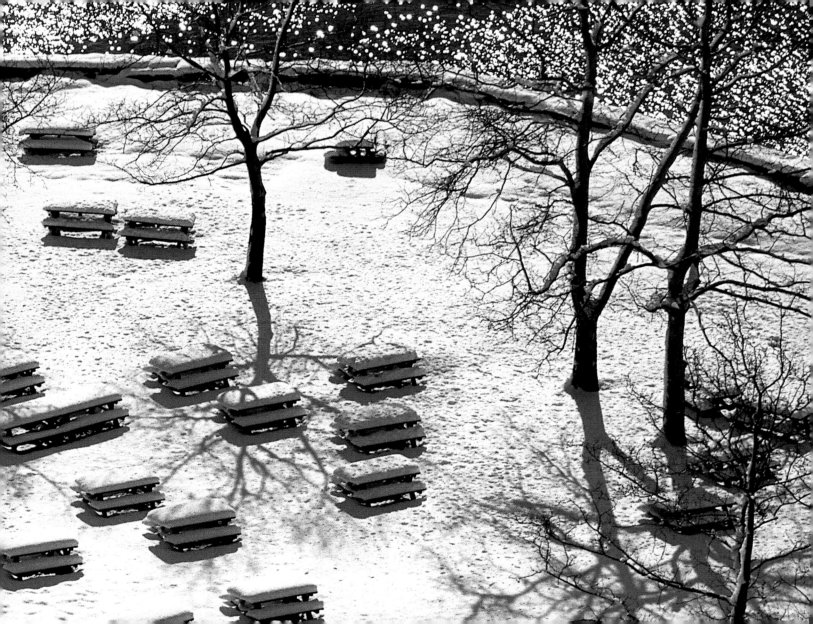

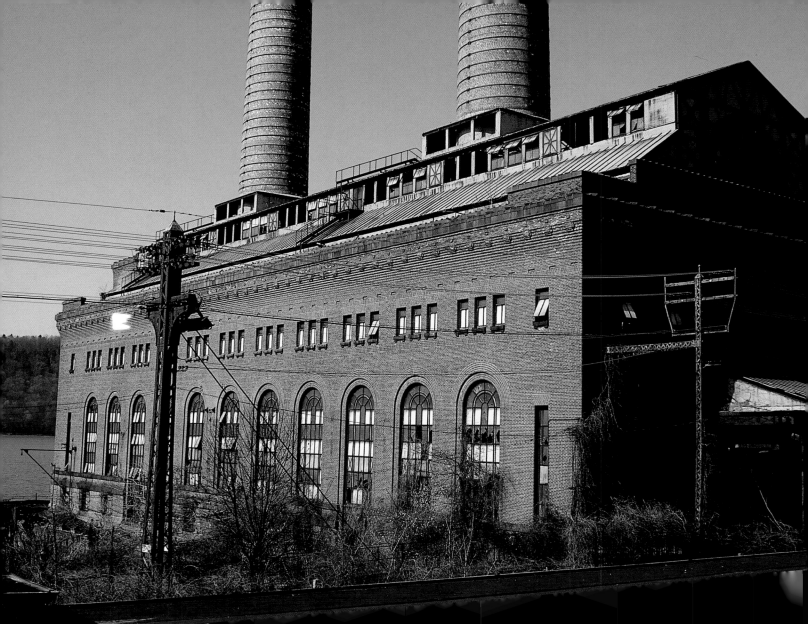

THE HUDSON HAS ALWAYS possessed that contradictory duality of aesthetics and industry: the nation's first great highway of commerce—whose history is written in smoke, brick, stream, and rail—yet somehow a river of constant beauty.

RAYMOND L. O'BRIEN, *American Sublime, 1981*

Factory in Yonkers. *Overleaf:* Wave Hill, The Bronx.

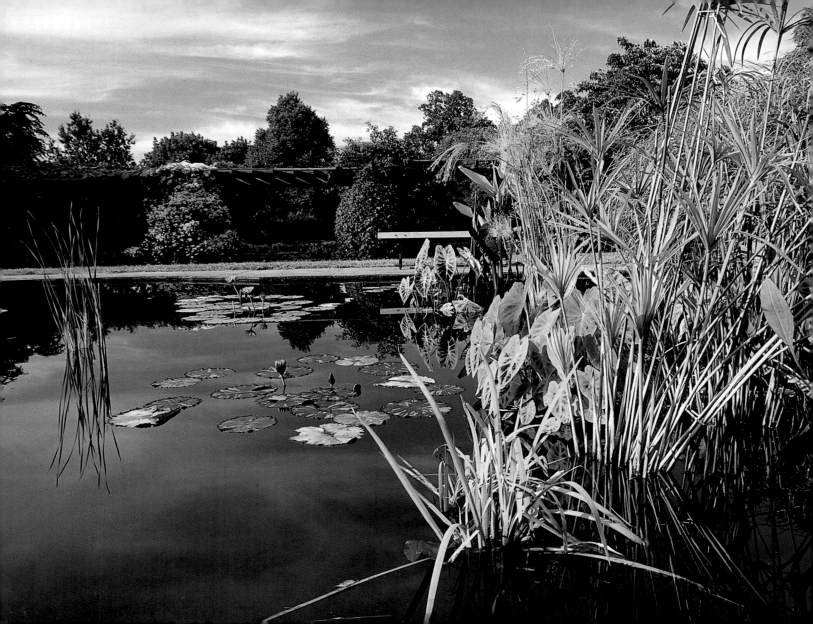

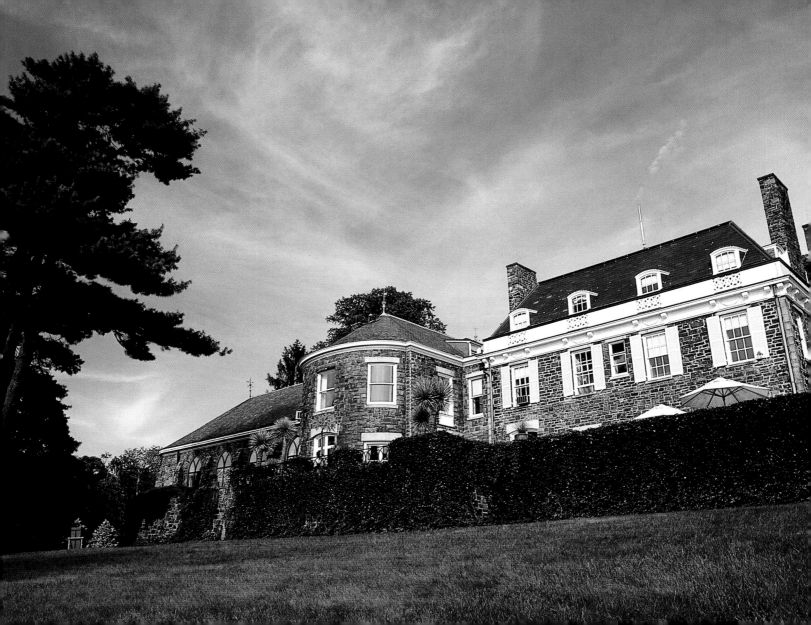

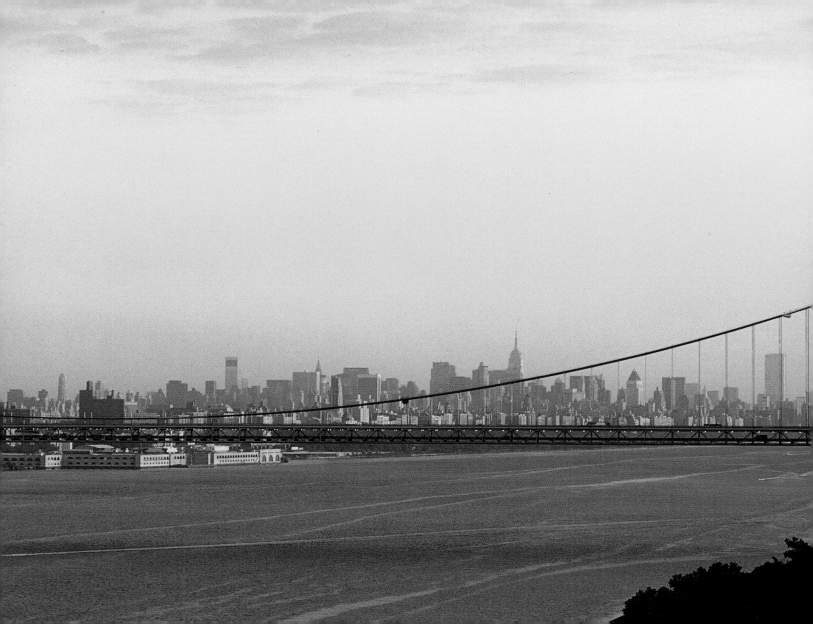

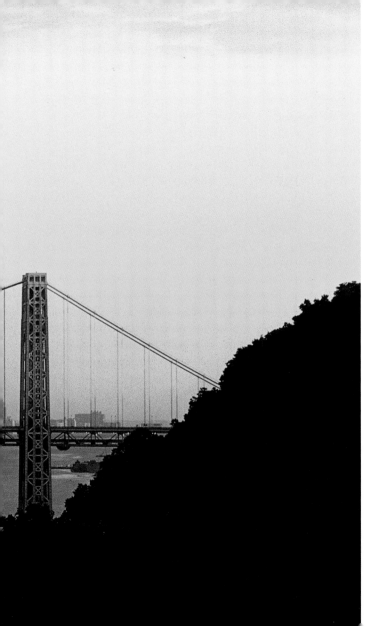

George Washington Bridge with Manhattan in the distance.

204

The Cloisters, Fort Tryon Park.

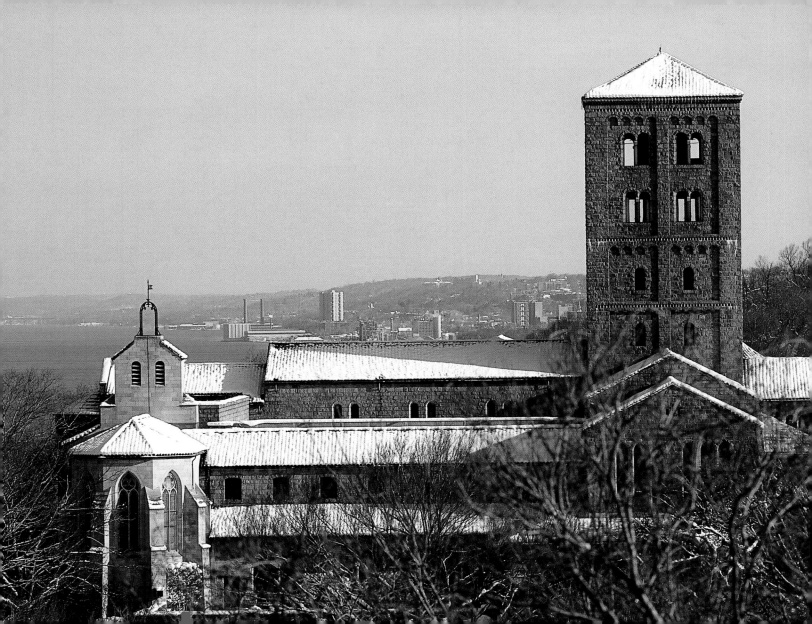

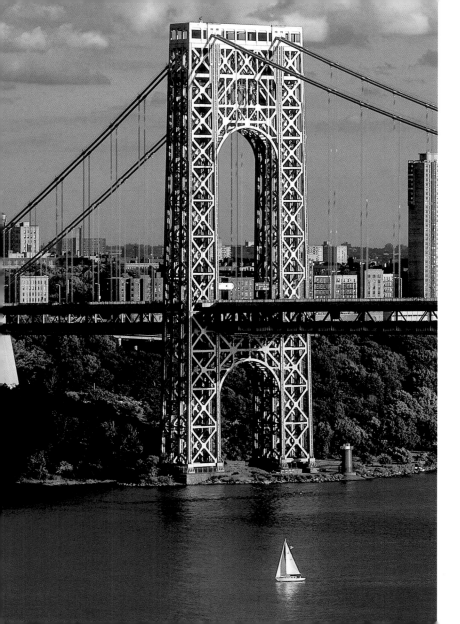

George Washington Bridge and the Little Red Lighthouse.

THE LITTLE RED LIGHTHOUSE knew that it was needed. The bridge wanted it. The man wanted it. The ships must need it still. It sent a long, bright flashing ray out into the night. One second on, two seconds off! Flash, flash, flash! Look out! Danger! Watch me! It called. Soon its bell was booming out too. Warn-ing! Warn-ing! It cried. The little red lighthouse still had work to do. And it was glad.

207

And now beside the great beacon of the bridge the small beam of the lighthouse still flashes. Beside the towering gray bridge the lighthouse still bravely stands. Though it knows now that it is little, it is still very, very proud.

HILDEGARDE H. SWIFT AND LYND WARD,
The Little Red Lighthouse and the Great Gray Bridge, 1942

Above: George Washington Bridge. *Opposite:* West Side of Manhattan.

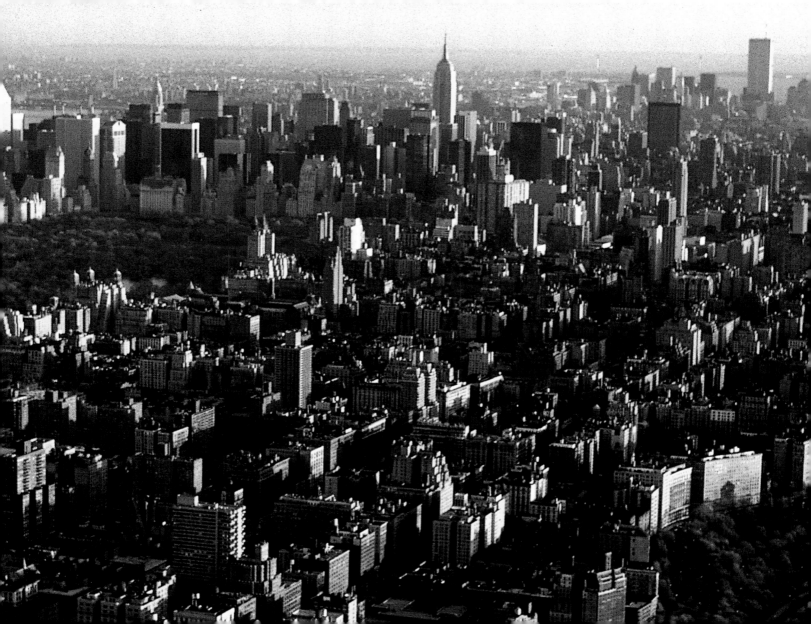

ONE SUNDAY IN 1914, Robert Moses was crossing the Hudson by ferry to picnic in New Jersey. With him were some college friends and their dates, one of whom was Frances Perkins, later the United States Secretary of Labor. As the ferry pulled out into the river, Moses leaned on the rail, watching Manhattan spread out behind the boat. Miss Perkins happened to be standing beside him and suddenly she heard Moses exclaim, "Isn't this a temptation to you? Couldn't this waterfront be the most beautiful thing in the world?" . . . Staring back at the bleak mud flats covered by a haze of smoke from the railroad engines, she heard Moses paint for her a picture of what the scene could be like on a Sunday—the ugly tracks completely hidden by the great highway, cars traveling slowly along it, their occupants enjoying the view, and

Riverside Park.

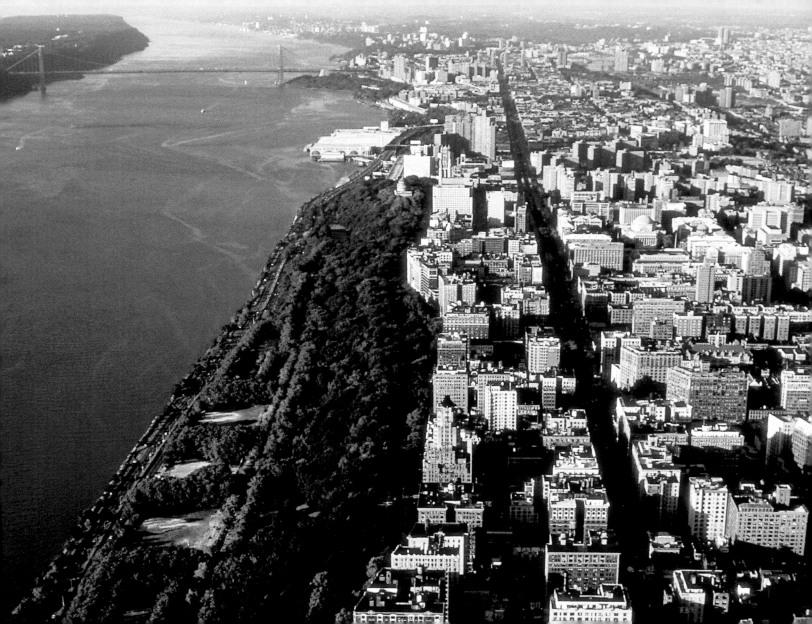

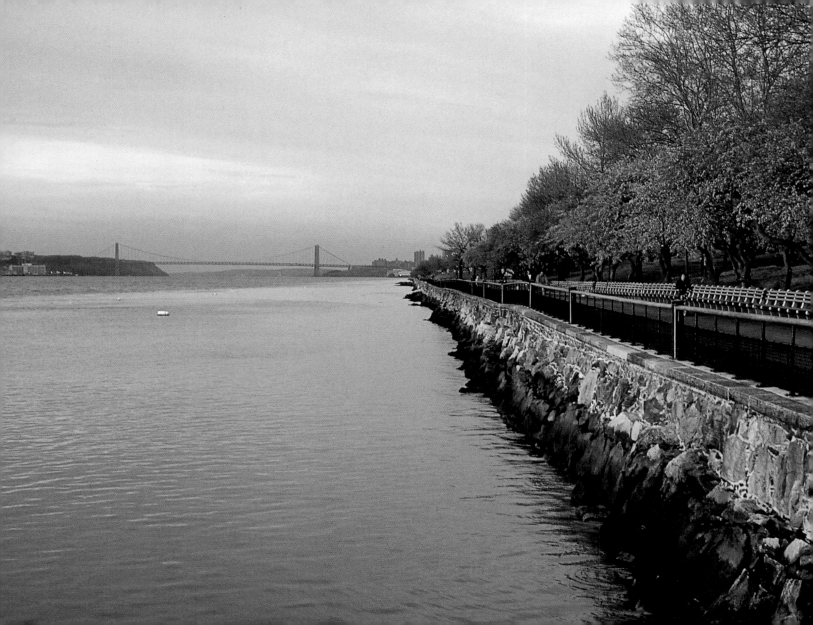

along the highway stretching green parks filled with strollers, tennis players and families on bicycles. There would be sailboats on the river and the motor yachts tied up in gracefully curving basins. And the thing that astonished her most, Miss Perkins was to recall, was that Bob Moses had the exact location of tennis courts and boat basins quite definitely in mind; the young Bureau staffer beside her was talking about a public improvement on a scale almost without precedent in turn-of-the-century urban America, an improvement that would solve a problem that had baffled successive city administration for years.

ROBERT A. CARO, *The Power Broker: Robert Moses and the Fall of New York, 1974*

Riverside Park.

214

Midtown Manhattan.

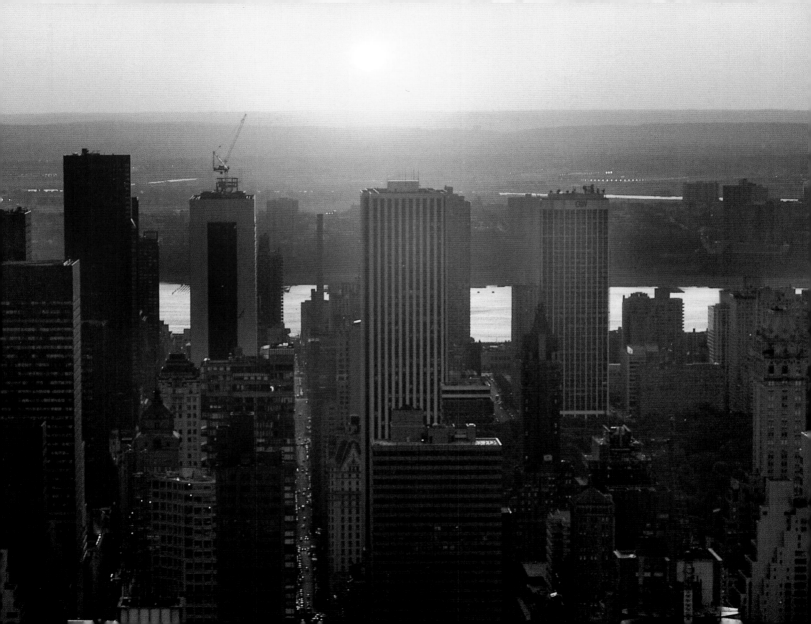

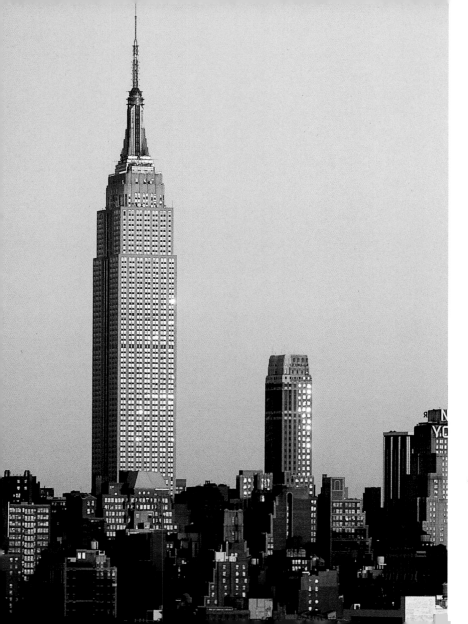

Left: Midtown Manhattan and the Empire State Building.
Opposite: Tugboat on the Hudson.
Overleaf: Westside Waterfront.

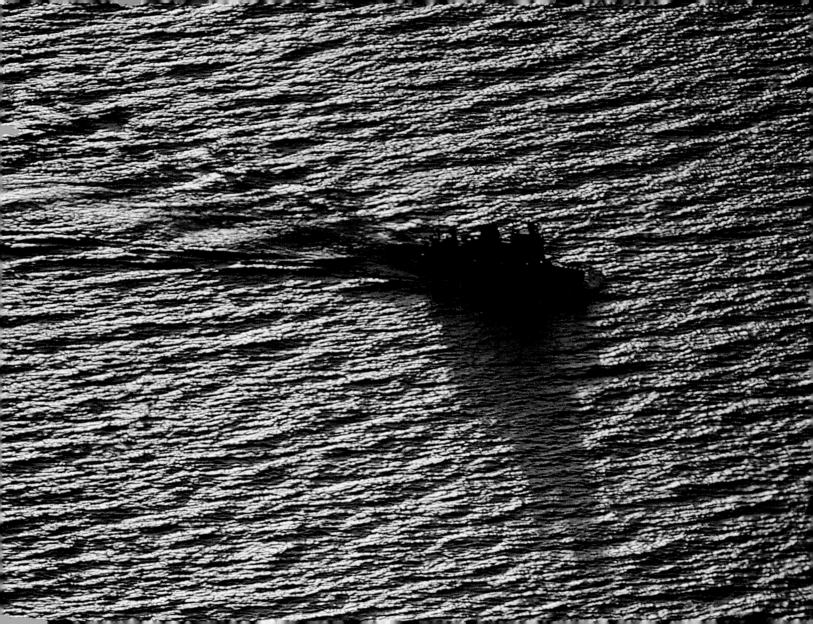

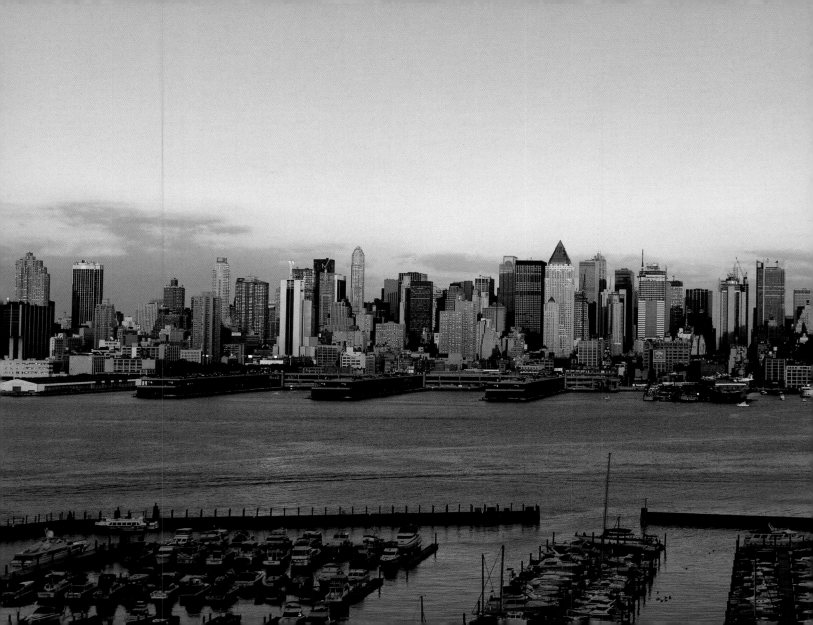

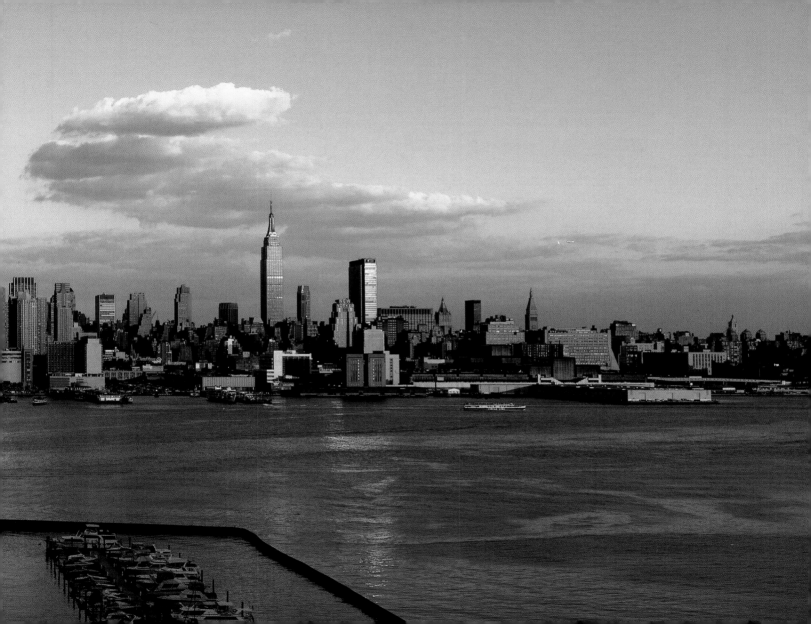

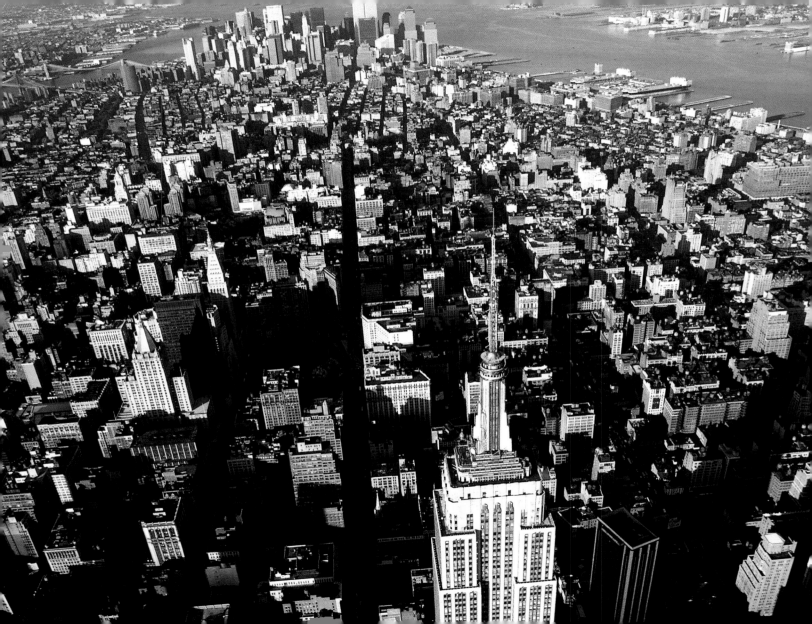

NEW YORK WAS the eastern terminus of our transcontinental flight. At first, one saw a distant off-colored patch of earth with the North Atlantic sweeping endlessly beyond. Then the scene hardened into streets and buildings and wharfs as we approached and descended . . . New York, symbolizing power, always brought my mind an intuition into conflict. When I first flew eastward to the city in my Spirit of St. Louis in 1927, I had experienced both repulsion and fascination. I was repulsed by its bigness, luxury, and artificial life, fascinated by the stupendous forces it commanded and by its influence in the material accomplishments of man.

CHARLES LINDBERGH, *Autobiography of Values, 1976*

221

Empire State Building.

Right: West Side waterfront.

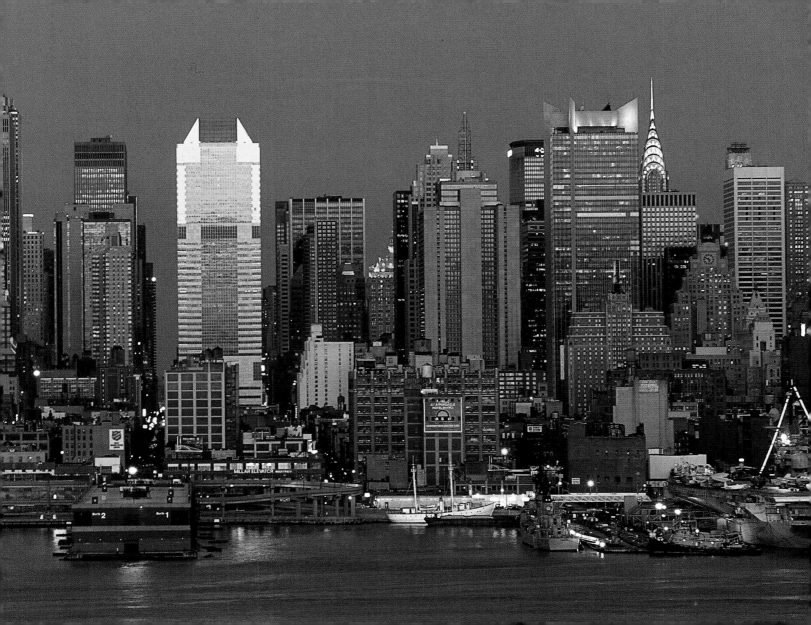

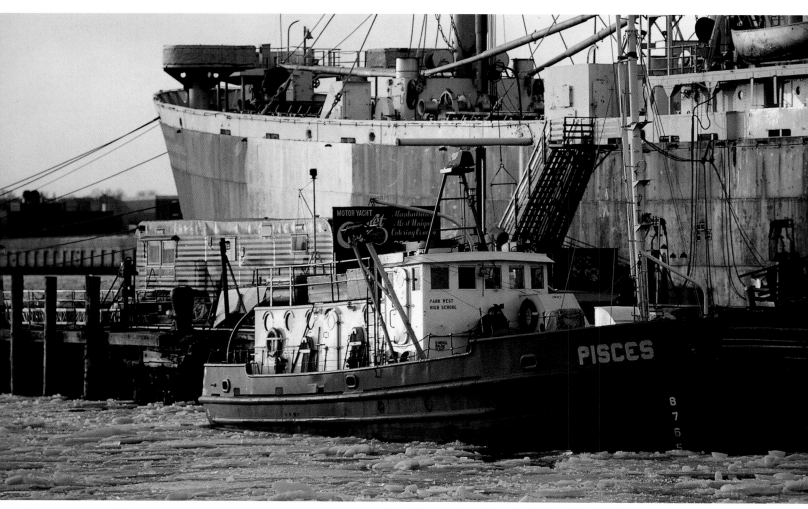

Above: Boats docked along the Hudson. *Opposite:* Manhattan from the west.
Overleaf: Silhouetted skyscrapers.

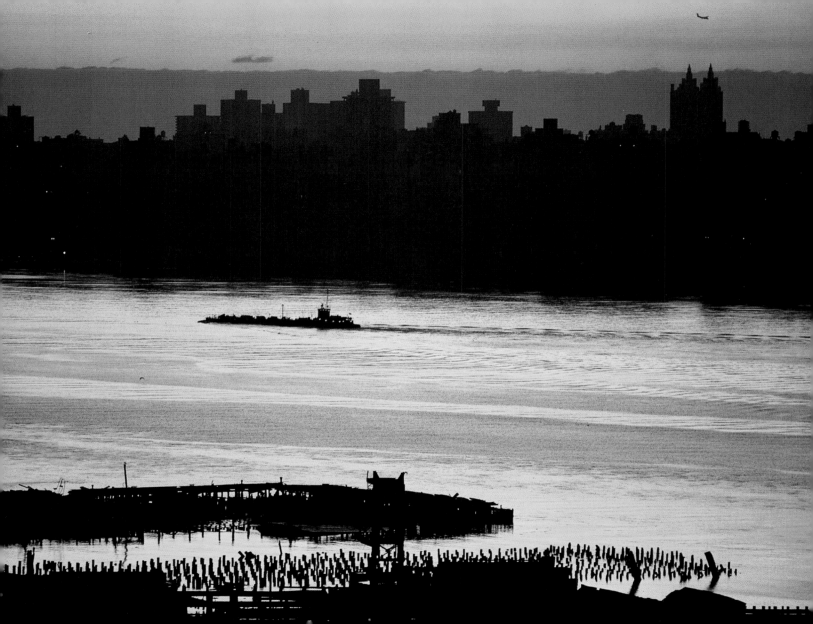

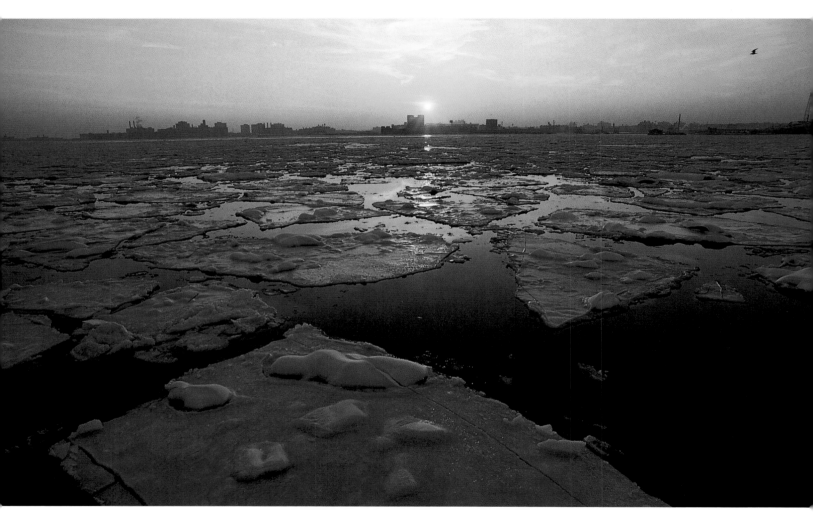

Ice breaking on the Hudson.

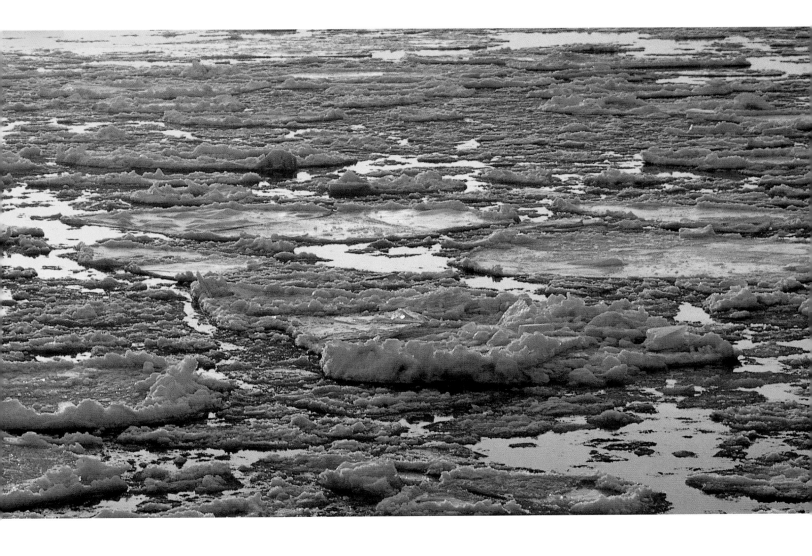

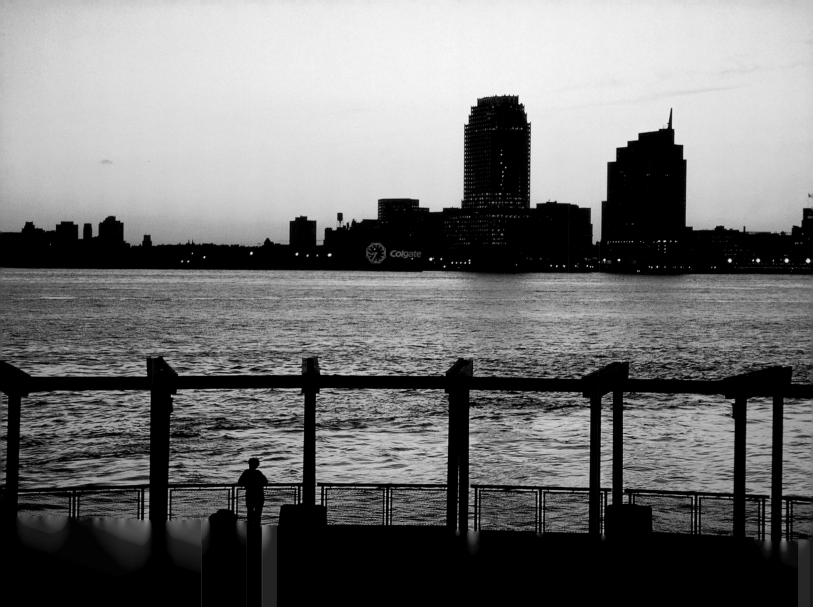

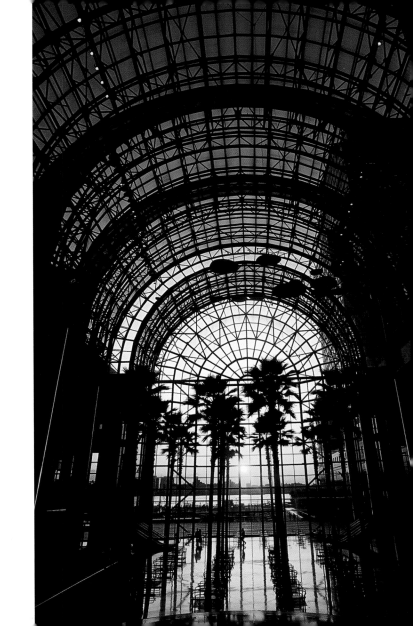

Right: World Financial Center. *Opposite:* New Jersey shoreline.

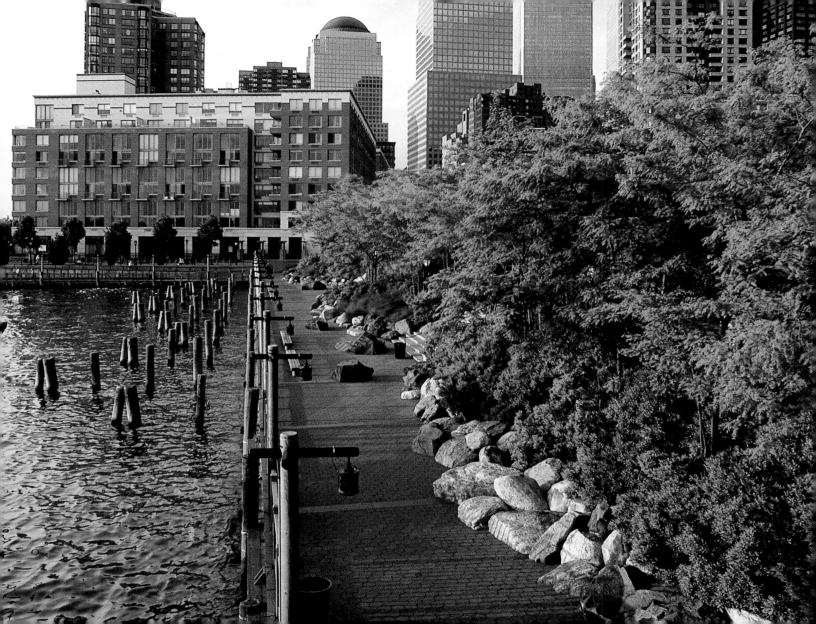

THE BEAUTIFUL METROPOLIS of America is by no means so clean a city as Boston, but many of its streets have the same characteristics; except that the houses are not quite so fresh-coloured, the sign-boards are not quite so gaudy, and the gilded letters not quite so golden, the bricks not quite so red, the stone not quite so white, the blinds and area railings not quite so green, the knobs and plates upon the street doors, not quite so bright and twinkling. There are many bye-streets, almost as neutral in clean colours, and positive in dirty ones, as bye-streets in London; and there is one quarter, commonly called the Five Points, which, in respect of filth and wretchedness, may be safely backed against Seven Dials, or any part of famed St. Giles's.

CHARLES DICKENS, *American Notes, for General Circulation, 1842*

South Cove, Battery Park City.

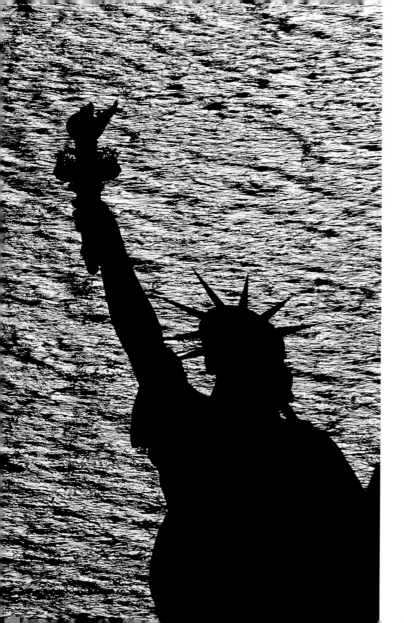

Left: Statue of Liberty. *Opposite:* Tugboat on the Hudson.
Overleaf: Ellis Island.

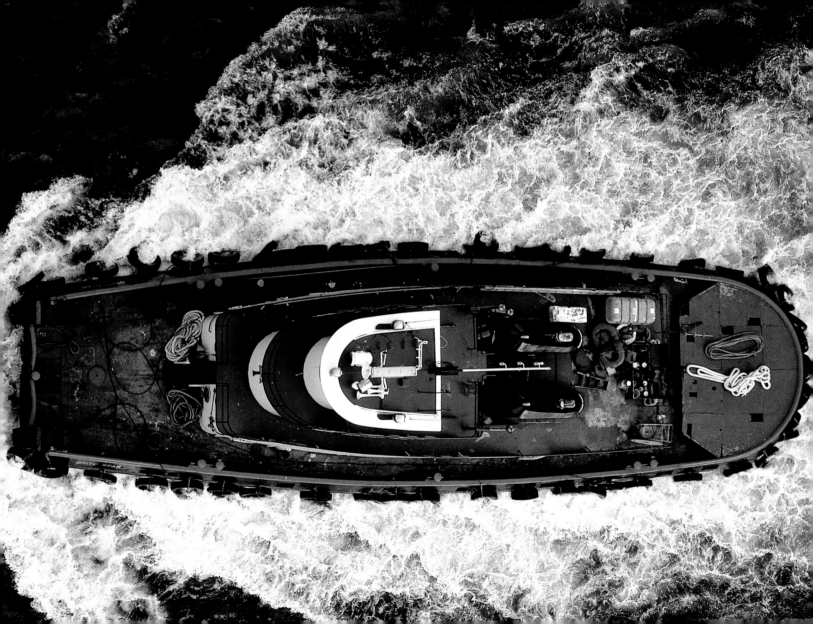

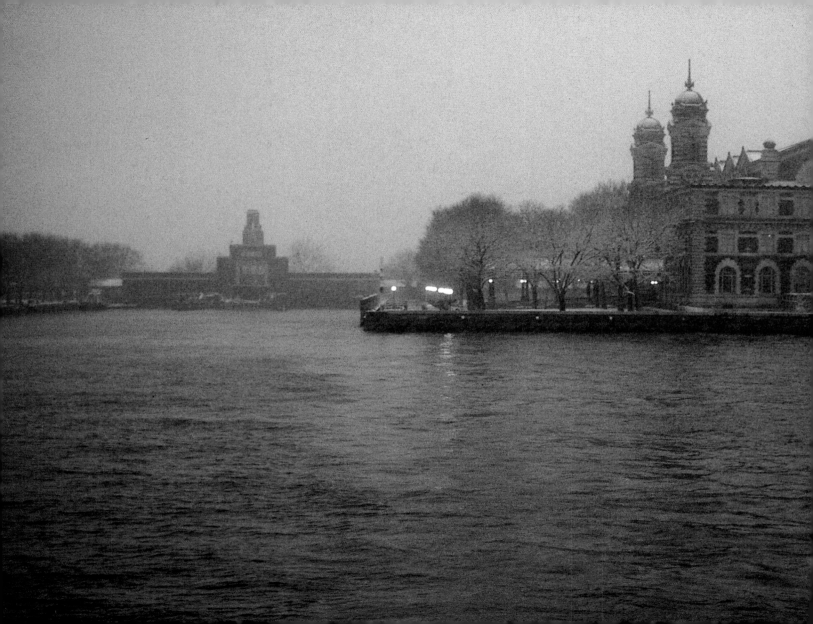

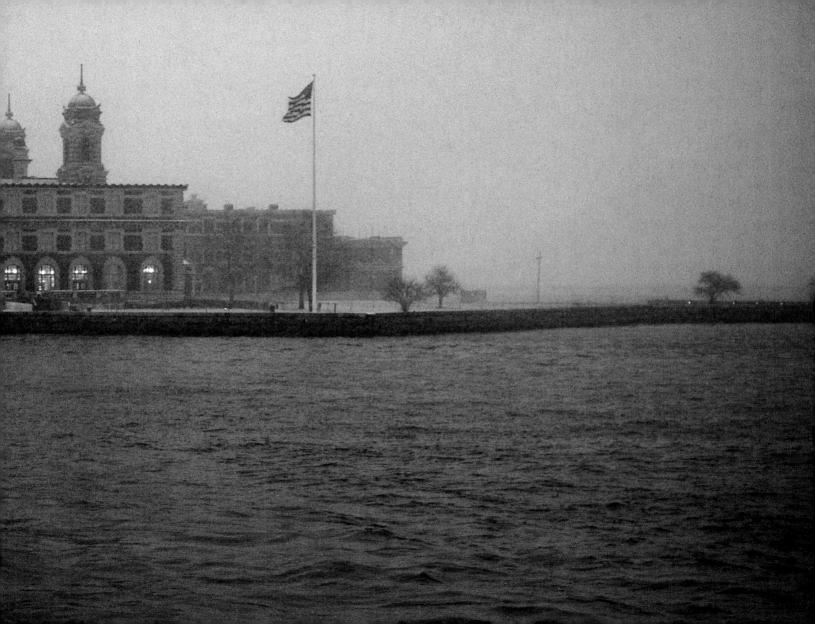

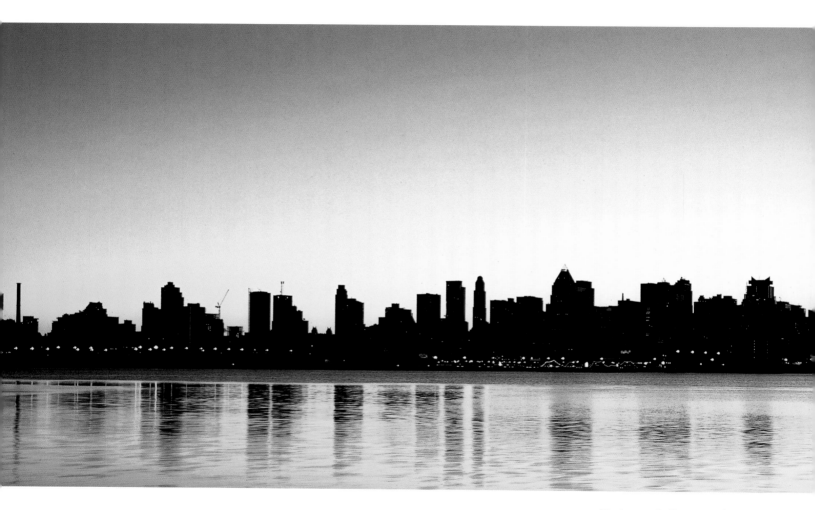

Manhattan skyline at sunrise.

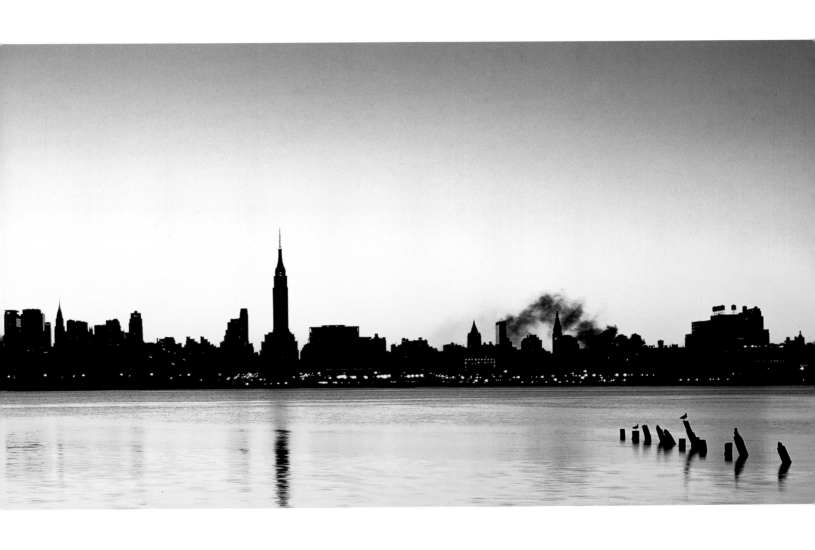

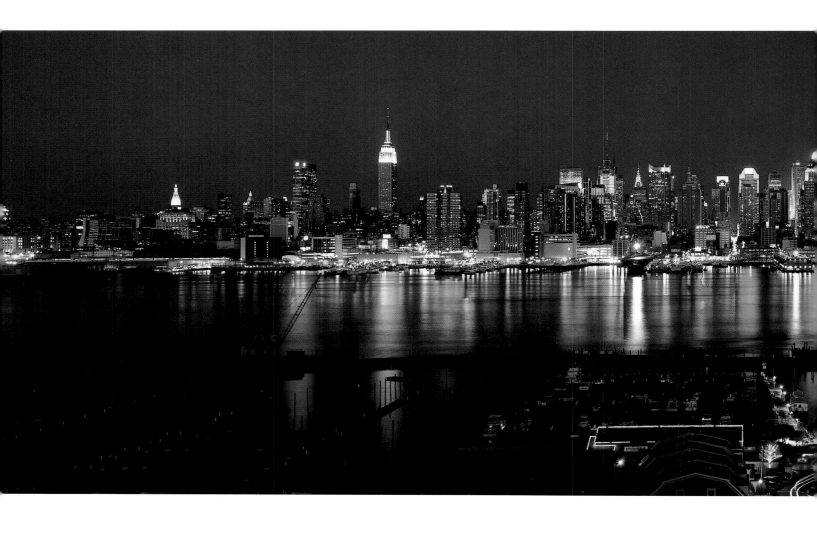

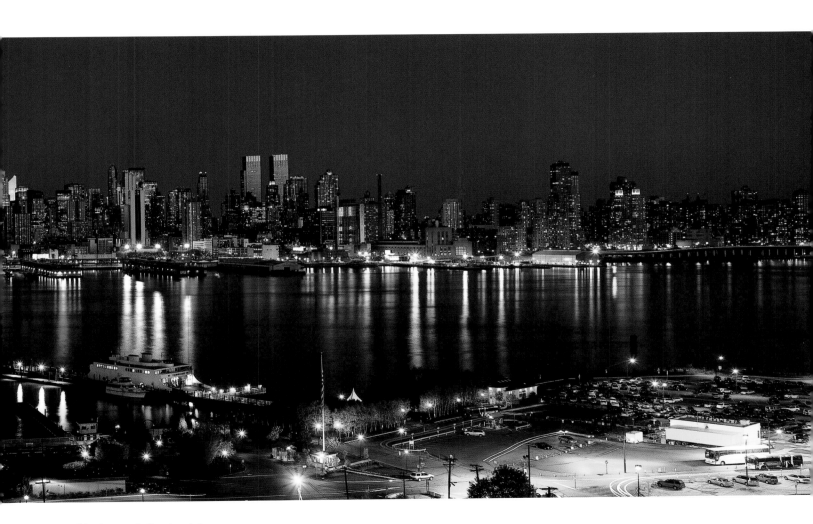

Manhattan skyline by night.

Statue of Liberty.

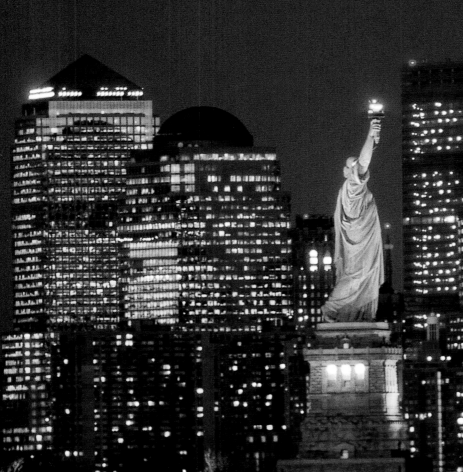

AFTERWORD EARLY WRITERS ON the Hudson River were greatly concerned with aesthetic principles and theories of the sublime, and the picturesque. The artists, architects, and landscapers of the Hudson River School gave great emphasis to these qualities. The photographs of Jake Rajs emphasize another aspect of the Hudson Valley—pure beauty. His pictures, whether a grand panorama from a mountaintop or a breathtaking aerial view over the metropolis, a simple flower or a river-rafting group, bring out the innate beauty in the object and the atmosphere. Truly he is working in the tradition of the luminists. Compiling an anthology of Hudson River writings to compliment Jake's pictures has also reopened my own eyes to the many aspects of beauty in the Hudson Valley. In these days of ecological concern, we too often forget the great beauty that still surrounds us. Too often we are blind to the familiar.

I have also revisited vast quantities of literature about the Hudson River with which I have long been very familiar—or so I thought until searching for harmonious correspondence between text and pictures. I have not followed any rigid plan in this selection, sometimes choosing a poem, a work of fiction, a traveler's account or history,

or art or architectural criticism. I would like to make the reader-viewer as appreciative of the unique qualities of this beautiful region as I have become over the many years of exploration of the region on foot, by automobile, by rail, and by water—over old dirt roads and abandoned rail lines, up obscure canals and creeks.

My family was active for generations in Hudson River steamboating and railroading with the Delaware & Hudson Company and the Hudson Navigation Co. An interest in steamboats and railroads and canals, the local industries they served, and their history came early in my life, and I was fortunate to travel with my father throughout the region starting at an early age. When I obtained a driver's license in the mid-1950s, one of the first things I did was obtain detailed government maps of the entire region between the Berkshires of New England and the Susquehanna River, and from the Adirondacks to the sea. I set out to travel every road, railway, and waterway in the region, including New York City and the metropolitan area. Since I have been in the sales business here for many years, I have come close to completing this ambitious plan. I have also become an active trail hiker, cartographer, and writer

of hiking guidebooks, and so I have learned the old and new trails of the Palisades, Highlands, Shawangunks, and Catskills, and their many hidden beauties. And I have always been an avid reader of history. This is without a doubt the most fascinating region of the United States in terms of local military, political, commercial, social, and artistic history. Anyone who lives in this rich region is fortunate.

I became active quite early in scenic preservation work and environmental advocacy with many local organizations. In the 1980s I served as the founding president of the Hudson River Maritime Museum at Kingston, and brought together their first board of directors from among such well-known Hudson River families as the Livingstons, Reeses, Smileys, Keppels, Ocotts, and Chanlers. I met the descendants of the founders of the great Hudson River manors and houses—and visited the houses themselves. In writing guidebooks I have come to know many lesser-known families with equally deep roots in the valley, unique local characters, and mighty contemporary historians.

I envy Jake his youth and his own opportunity to have come to know the

Hudson. I learned the river from the decks of a sidewheel steamboat, from hours spent learning to be a river pilot; Jake has become similarly acquainted with the roads, hills, mountains, streams, trails, and above all, the beauty and the interest of the Hudson. I sincerely hope he will continue to bring his "eye for beauty" to many more locations in the region.

Finally, while we have artisans, artists, citizen groups, and individuals working to protect the river from pollution and other harm, much remains to be done to preserve our beautiful homeland. We must continue to clean the river and to protect wildlife. We must control urban sprawl and litter. We must maintain and groom hiking trails and parks. We must restore and protect historic buildings and maintain our lighthouses. We must preserve our cultural and technological heritage in libraries and museums. We must bring day-passenger steamers back to the river and judiciously restore and expand the railway networks.

The work is endless; the rewards are infinite. I hope that visiting the Hudson Valley through this book will inspire you to join in the unending great work. *Arthur G. Adams*

POSTSCRIPT

THE HEALTH OF THE EYE SEEMS TO DEMAND A HORIZON.
WE ARE NEVER TIRED, SO LONG AS WE CAN SEE FAR ENOUGH.
RALPH WALDO EMERSON, *1836*

A PHOTOGRAPHIC BOOK is a visual story, a record of how far the eye can see. This book captures, I hope, the farthest reaches of my vision throughout the Hudson region. The river was a subject of my early photography, and the photographs in this book were taken over more than fifteen years. The beauty of the river forced me to explore it, as it had, I like to think, Henry Hudson, the Hudson River school of artists, and those who wrote of it so eloquently (whose writings are excerpted throughout this book).

I discovered the Hudson as an eight-year-old, when I arrived in New York Harbor after a two-week voyage from Israel. Since then, I've lived in Manhattan, Brooklyn, New Jersey, and the Catskills. As I grew older my interest in and knowledge

of the river increased. My boyhood friends and I discovered nature there; we explored its wild banks and watched spectacular sunsets. Crossing the river into the "big city" was an important ritual for a young photographer: it represented a journey to the center of the creative world. I've hiked many of the peaks of the Highlands and the region's mountain ranges; in the last five years I've made two treks to the very source of the river, Lake Tear of the Clouds in Adirondack Park. My first camping trip was in the Catskill Mountains; lying beside a lake and looking up to the millions of stars—the first time I saw them free of the city's light pollution—I felt the joy that comes from nature, and which I have always tried to keep at the forefront of my photography.

Today this joy is the prize in the battle between the preservationists and the developers, fortunately for the most part won by the former. Yet the challenge—to create responsible, controlled development that threatens neither the natural beauty or human community—still remains. I hope these photographs inspire others as the Hudson inspired me, so that the natural beauty of the land will be enhanced and preserved for future generations. *Jake Rajs*

First published in the United States of America in 2006 by
The Monacelli Press, Inc.
611 Broadway
New York, New York 10012

Library of Congress Cataloging-in-Publication Data

Rajs, Jake.
 The Hudson River : from Tear of the Clouds to Manhattan / Jake Rajs ;
introduction by Joan K. Davidson ; afterword by Arthur G. Adams.— 1st ed.
 p. cm.
 ISBN 1-58093-172-3
 1. Hudson River Valley (N.Y. and N.J.)—Pictorial works. 2. Hudson River
(N.Y. and N.J.)—Pictorial works. I. Title.
 F127.H8R193 2006
 974.7'30440222—dc22
 2005029388

Design: John Klotnia and Brian Magner, Opto Design

Printed and bound in China